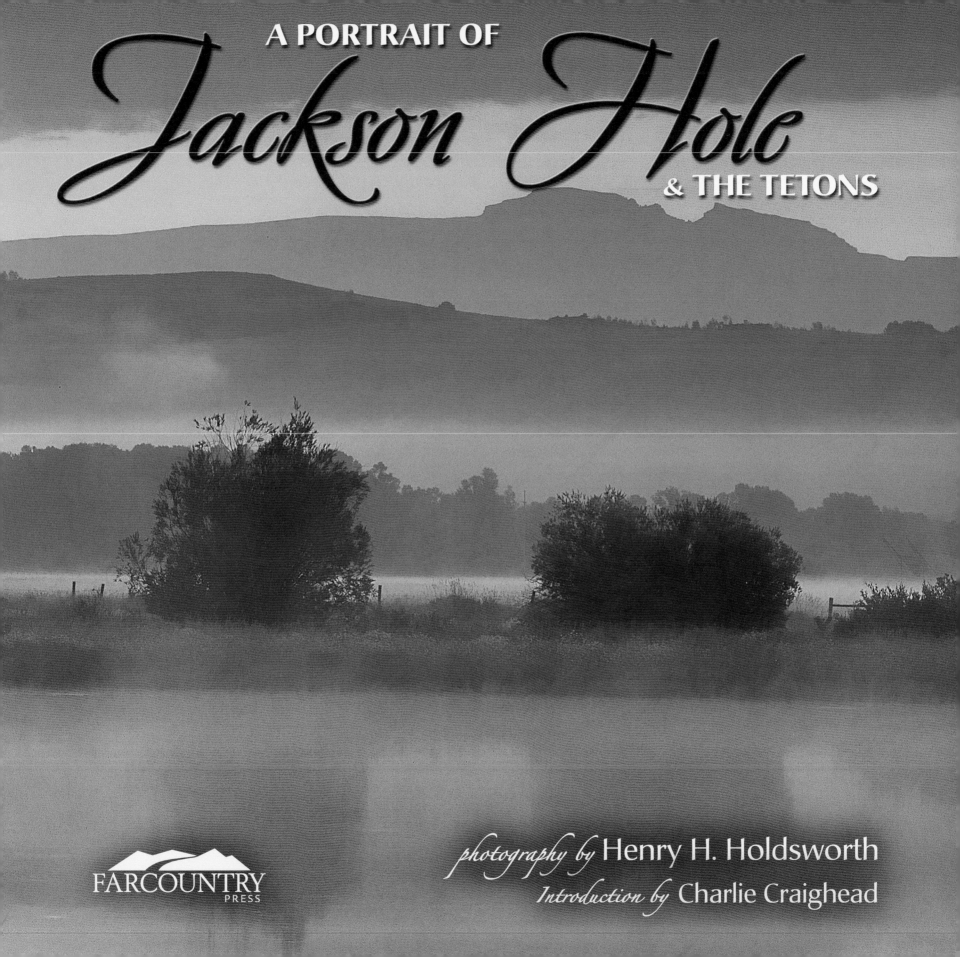

A PORTRAIT OF

Jackson Hole

& THE TETONS

photography by Henry H. Holdsworth

Introduction by Charlie Craighead

FARCOUNTRY
PRESS

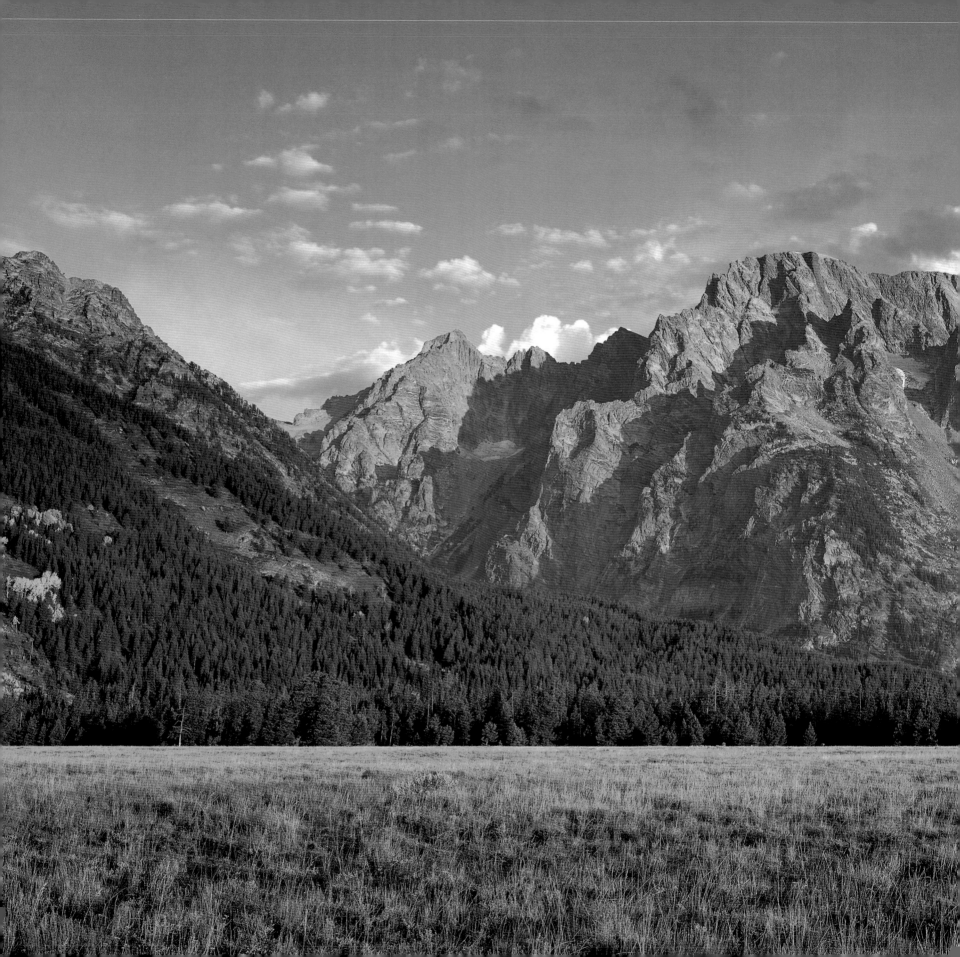

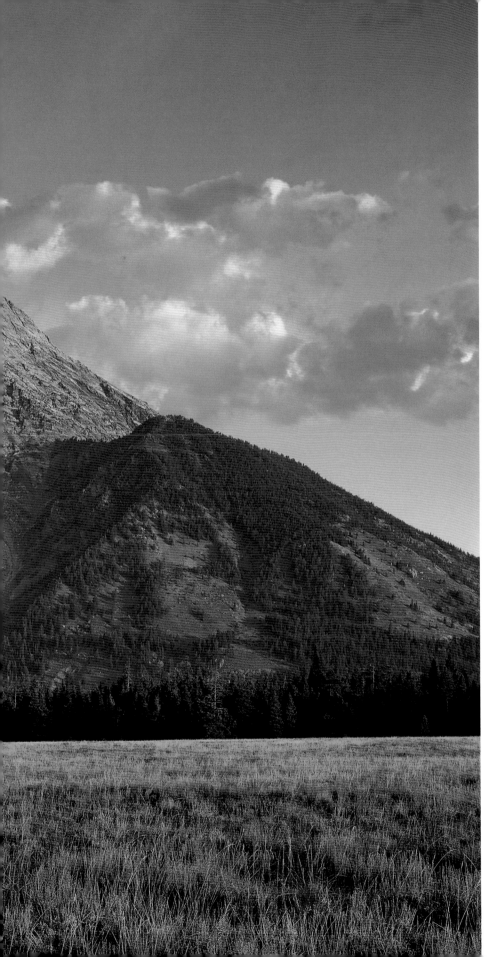

Dedication

To my father, John, who was always ready for a Jackson Hole adventure.

Left: A warm autumn glow bathes Mount Moran and a meadow near Jenny Lake Lodge in Grand Teton National Park. Located on the Jenny Lake Loop Road near the Cathedral Group turnout, this is an excellent place to hear the elk bugle in September and October.

Title page: Indian Dreams. The Sleeping Indian (also known as Sheep Mountain) rests peacefully as dawn filters into Jackson Hole.

Front cover: The Teton Range rises above a nodding field of wildflowers near Mormon Row in Grand Teton National Park.

Back cover, top: Haystacks in the shape of bread loaves dot the Walton Ranch at the end of summer.

Back cover, bottom: A pair of trumpeter swans swims along Flat Creek where the National Elk Refuge borders the town of Jackson.

Front flap: Eyes of the hunter: A great gray owl flies through a meadow in Grand Teton National Park. North America's largest owl at thirty-three inches tall, the great gray is one of the few owls that occasionally hunts during daylight hours.

ISBN 10: 1-56037-409-8
ISBN 13: 978-1-56037-409-1

© 2007 by Farcountry Press
Photography © 2007 by Henry H. Holdsworth

For more information about our books, write Farcountry Press, P.O. Box 5630, Helena, MT 59604; call (800) 821-3874; or visit www.farcountrypress.com.

Created, produced, and designed in the United States.
Printed in China.

12 11 10 09 08 07 1 2 3 4 5 6

INTRODUCTION

by Charlie Craighead

Imagine, for a moment, following mountain man David E. "Davey" Jackson as he traveled through this valley in the mid-1820s—watching him on a moonlit dawn as he waded into an ice-cold beaver pond, or peering over his shoulder on a June morning as he dug his knife blade into the glacial soil for blue camas bulbs to supplement his diet. What did the valley look like when it was absolutely wild, the air so clear it seemed to magnify every face and fracture of the Tetons? Were the sun-rises and sunsets the same hues as ours? And

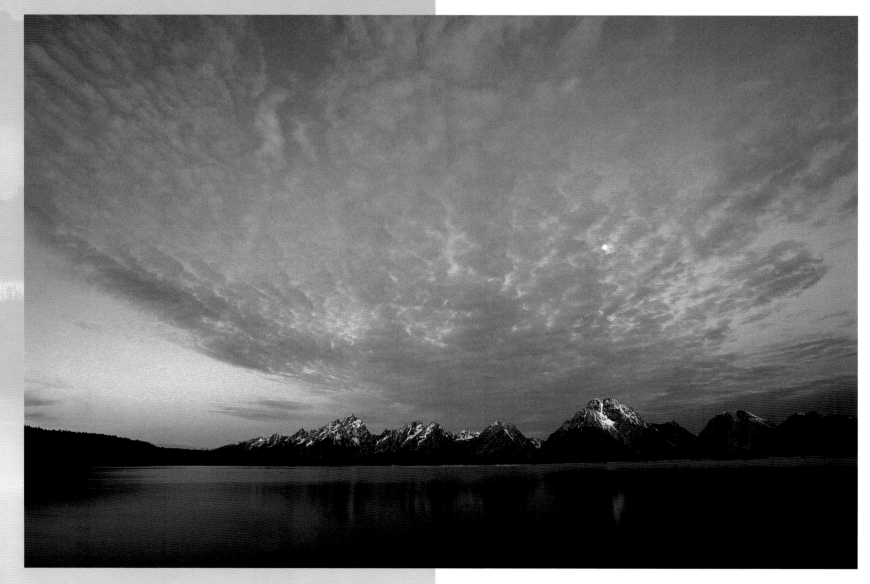

A full moon at dawn floats over Jackson Lake, the valley's largest lake—and a favorite spot for summer and winter recreation, including boating and windsurfing, cross-country skiing, and ice-fishing.

when Jackson arrived at Burnt Fork in 1825 for the annual fur trader rendezvous, how would he describe the valley that would later bear his name? Could he put the landscape into words, or did he try to scratch a drawing of the Tetons in the sand along Burnt Fork?

The effort to describe Jackson's Hole, as it was first known, was limited for many years to word of mouth by American Indians or fur trappers, or to the official jargon of geological reports. It wasn't until 1872 that the first photographs were taken of the Tetons, when William H. Jackson scrambled up the west side to a vantage point just south of the main peaks. His primitive black-and-white images record the improbable rise and stark immensity of the peaks, but not the bright meadows of alpine wildflowers or the pink granite near the summits.

A few years later, in November 1876, Lieutenant Gustavus C. Doane led a small group of soldiers on a winter trip through Jackson Hole. He had no camera and no artist among his crew, so relied on his journal to record his impressions. Despite the fact that he and his men nearly starved to death, his words reveal his enthusiasm for the landscape:

> The moonlight view was one of unspeakable grandeur. There are twenty-two summits in the line, all of them mighty mountains, with the gleaming spire of Mount Hayden rising in a pinnacle above all. There are no foothills to the Tetons. They rise suddenly in rugged majesty from the rock strewn plain. Masses of heavy forest appear on the glacial debris and in parks behind the curves of the lower slopes, but the general field of vision is glittering glaciated rock. The soft light floods the great expanse of the

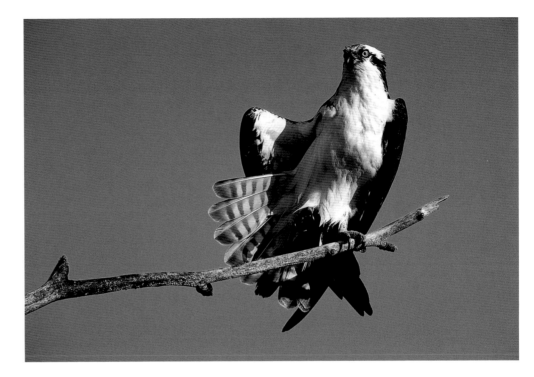

An osprey stretches its tail feathers in the morning sun. These fish hawks, as they are known, and their large nests are a common sight along many of Jackson Hole's highways and waterways.

valley, the winding silvery river and the resplendent deeply carved mountain walls.

In 1884, the first permanent white settlers came to Jackson Hole and homesteaded the southern end of the valley. Most of their time was taken up with survival, but one early arrival, Stephen N. Leek, brought photography to the pioneer community in 1887 and began documenting life and wildlife in Jackson Hole. The world's view of this picturesque valley would never be the same. By the time Grand Teton National Park was established in 1929, photographers and their cameras found permanent homes at the base of the Tetons.

Over the ensuing years, the Jackson Hole valley was documented, mapped, described, painted, and photographed in every conceivable way. While some artists and photographers have succeeded in capturing a bit of the valley's subtle magic, most concentrated on trying to work

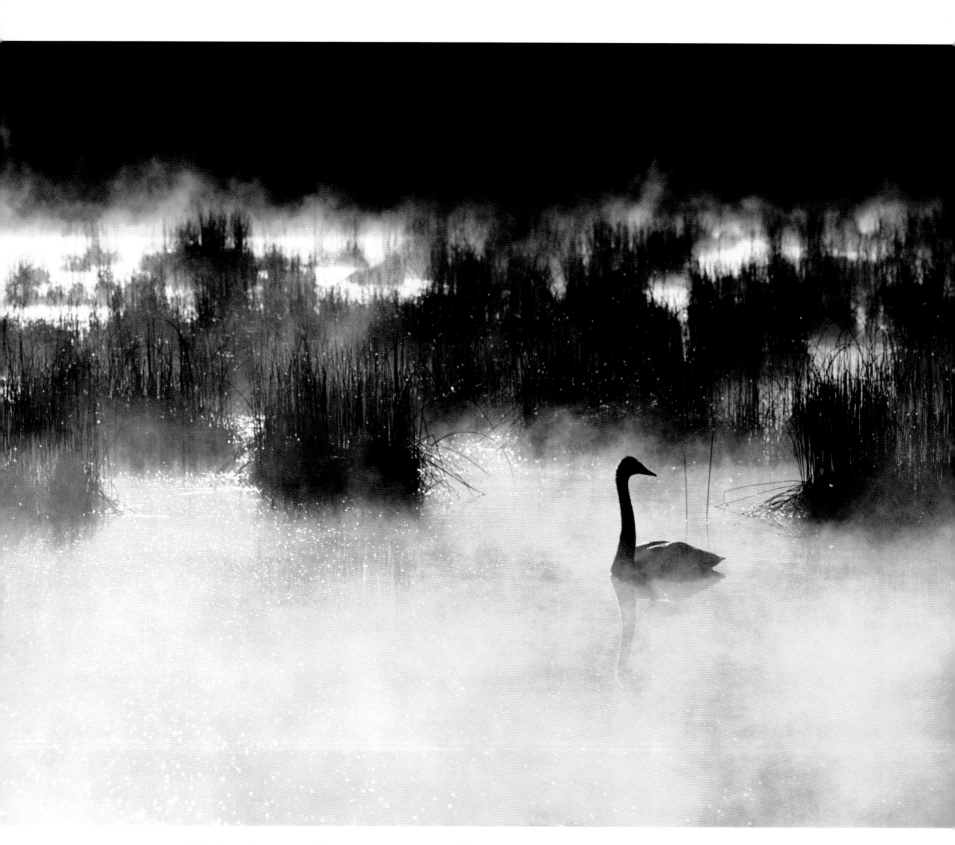

Morning mist surrounds a trumpeter swan on Christian Pond near Jackson Lake Lodge. The largest waterfowl in North America, these majestic white birds are year-round Jackson Hole residents.

with the towering effect of the Tetons. Several scenes have come to represent Jackson Hole—the Cathedral Group, Jenny Lake and Cascade Canyon, Mount Moran across the broad expanse of Jackson Lake, and the view from the Snake River Overlook, made famous by Ansel Adams.

Where those early photographers explored the structure and composition of the scenery, and then the vivid alpine colors of sky, glacial water, and wildflowers, Henry Holdsworth unveils the more subtle colors and elusive moods of Jackson Hole. Artists who spend much time in Jackson Hole soon learn that the valley has a personality and rhythm of its own, beyond the sunrise depictions of its gneiss and granite peaks or bull elk sparring in September. Mood and color change by the minute. Fog, mist, and clouds, driven by almost visible winds, wrap the scenery at odd moments, shifting and reflecting the light into unlit corners of the entire valley. For a photographer, following this mercurial spectrum through Jackson Hole can become a passion. For a gifted nature and wildlife photographer like Henry Holdsworth, the chase is usually rewarded with perfect compositions of wildlife, color, and landscape.

In spite of the protection of Grand Teton National Park and adjacent wilderness areas and national forest lands, Jackson Hole is no longer the wild place that it was when Davey Jackson visited. A few elements of the land, though, still appear just as Jackson saw them, and Henry Holdsworth's panoramic views give us a glimpse of that pristine time. But with this book, *A Portrait of Jackson Hole & the Tetons,* Holdsworth also combines the wild and beautiful with reminders of our own place in the valley's long history. Signs of human settlement, both past and present, take their place beside bison and mule deer.

This book is a visual treasure of the natural world and a source of inspiration, as well as a plea to maintain Jackson Hole's tradition of blending wild landscapes with authentic western history. The Tetons and their lakes, the ospreys and eagles, and the rainbow over the Snake River will be here, but we also need the edge of a meadow where a solitary fence post marks an old homestead, the outline of a hand-built log cabin, and a hay field blending into aspen-covered foothills.

Henry Holdsworth has beautifully and gently reminded us of the balance of life in present-day Jackson Hole and given us direction for the years ahead.

෴

Charlie Craighead, from Moose, Wyoming, is a writer and filmmaker who grew up in a family of biologists. He has worked for National Geographic, *Wolfgang Bayer, and the Discovery Channel and has written books on subjects ranging from the Grand Canyon to mountaineer Glenn Exum. His recent work includes a guidebook series for Grand Teton National Park and a book on the historic Wort Hotel in Jackson, Wyoming, titled* Meet Me at the Wort.

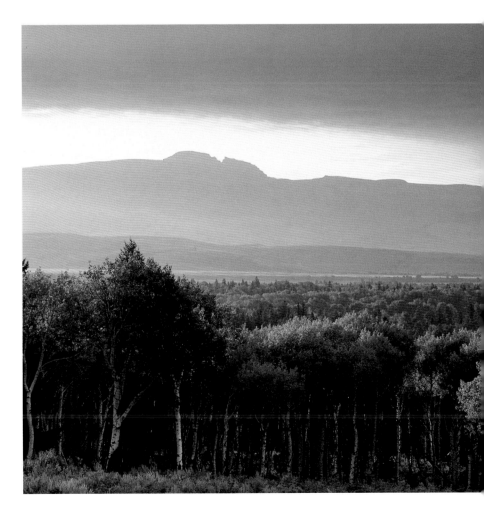

Aspen trees near Granite Canyon soak up early morning light as the Sleeping Indian snoozes on the valley's far side.

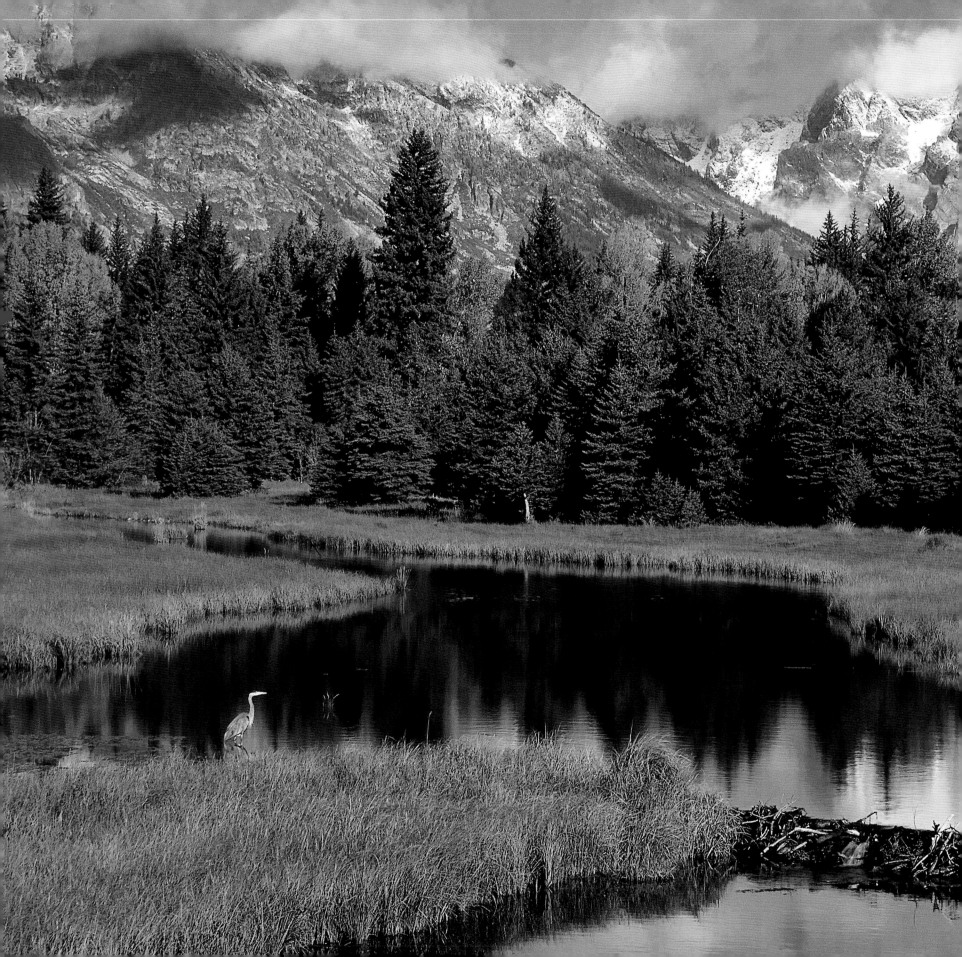

Left: Hints of fall surround a great blue heron fishing in the shallows of a beaver pond at Schwabacher's Landing.

Below: A moose cow and calf feed on aquatic plants in a pond in Grand Teton National Park. Seeing a chocolate-brown baby moose is the highlight of many a summer visit to the park.

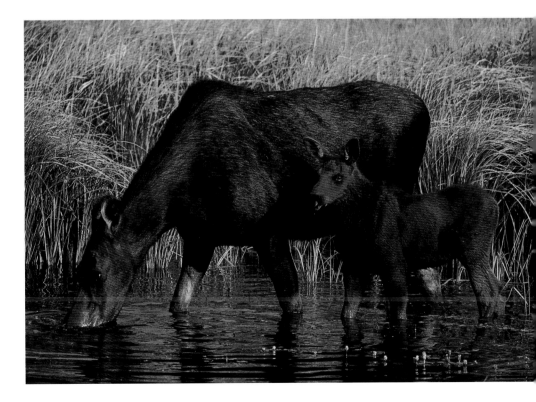

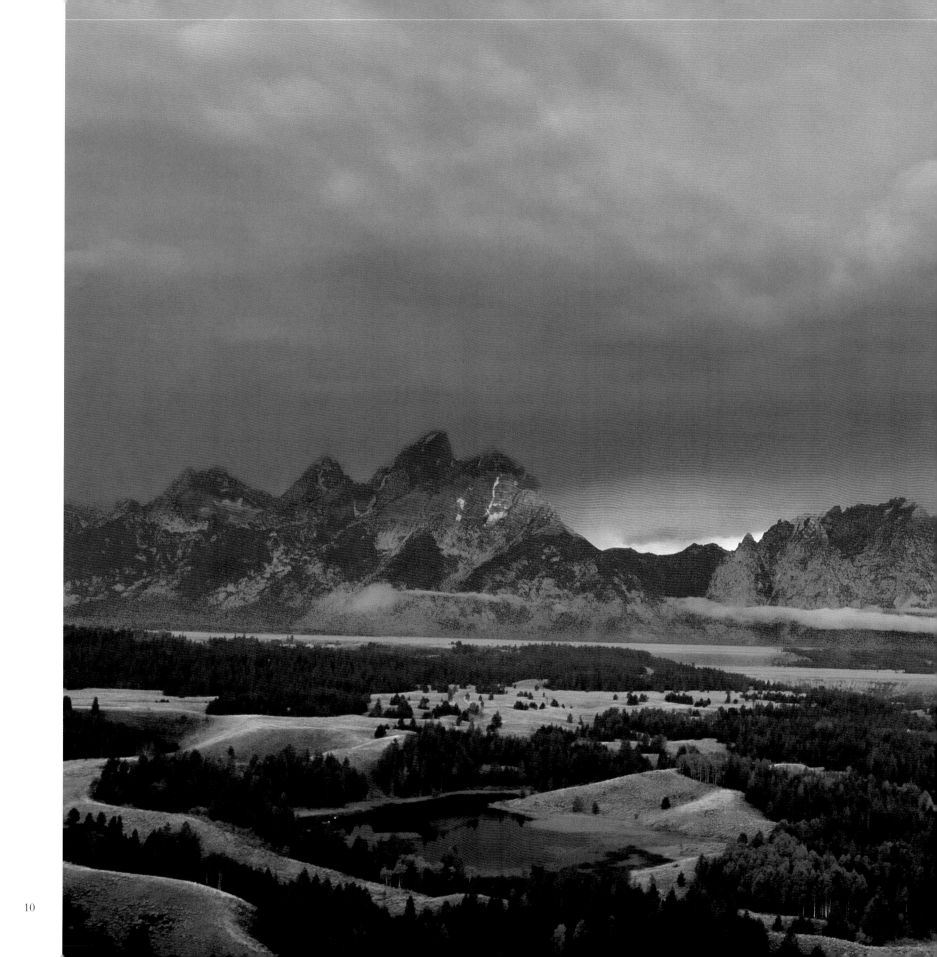

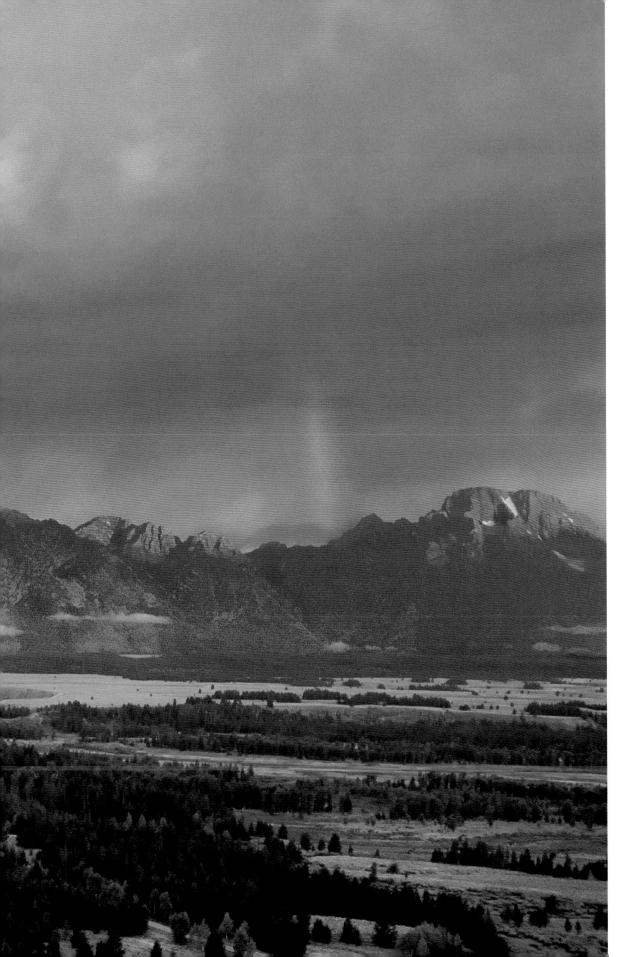

Sunrise reveals the exquisite beauty
of an approaching thunderstorm
over the Teton Range.

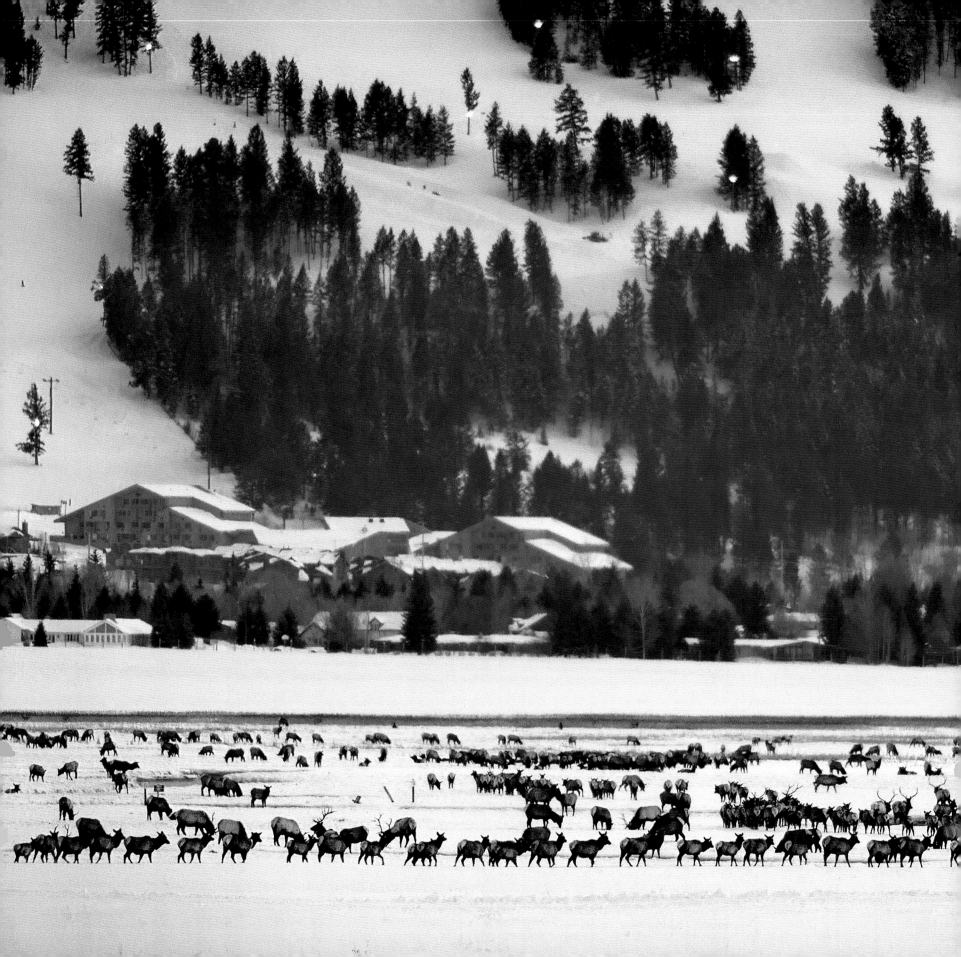

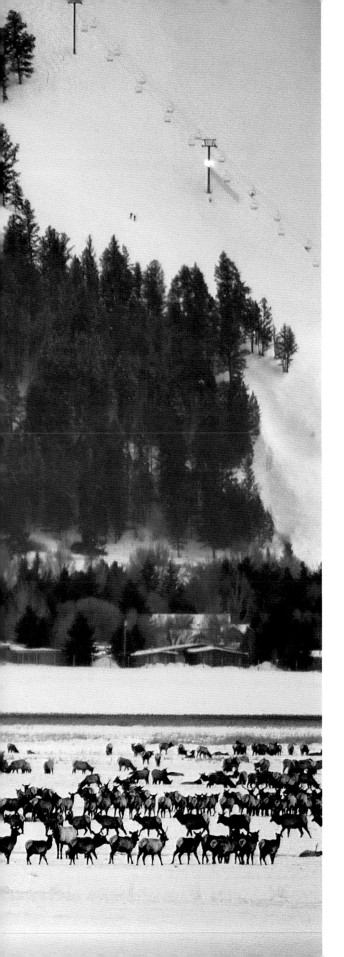

Left: Skiers on Snow King Mountain can look out over an average of 7,500 elk on the National Elk Refuge below. The refuge was established in 1912 to provide winter habitat for one of North America's largest elk herds. Snow King Ski Area, which was founded in 1939, was the first ski resort in Jackson Hole and one of the first in the United States.

Below: A mature bull moose blends into the sagebrush during an early winter snowstorm near aptly named Moose, Wyoming. Bulls drop their antlers from mid-December to early January and begin growing a new set each spring.

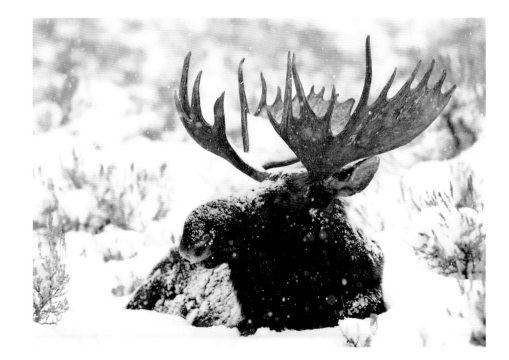

13

Right: A young black bear dines on a meal of hawthorne berries along the Moose–Wilson Road in Grand Teton National Park. In early fall, bears eat as much as they can to fatten up for a long winter's sleep.

Below: Asters and Lewis monkeyflowers thrive during the short summer in the Tetons. The months of July and August bring amazing displays of color to the alpine regions.

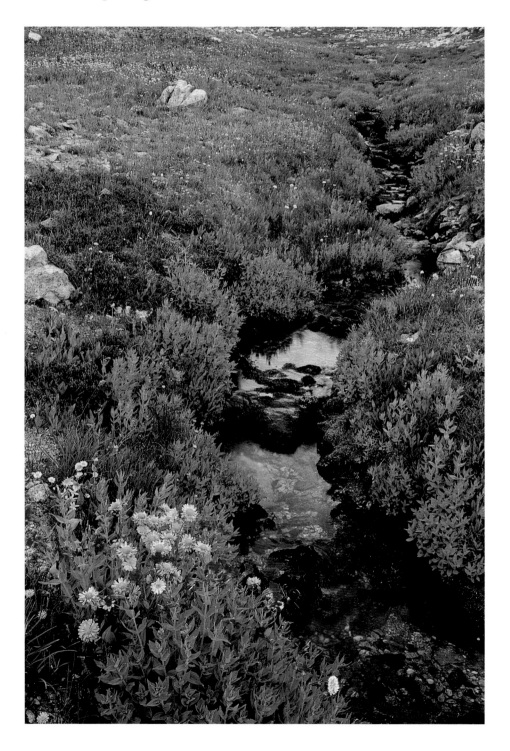

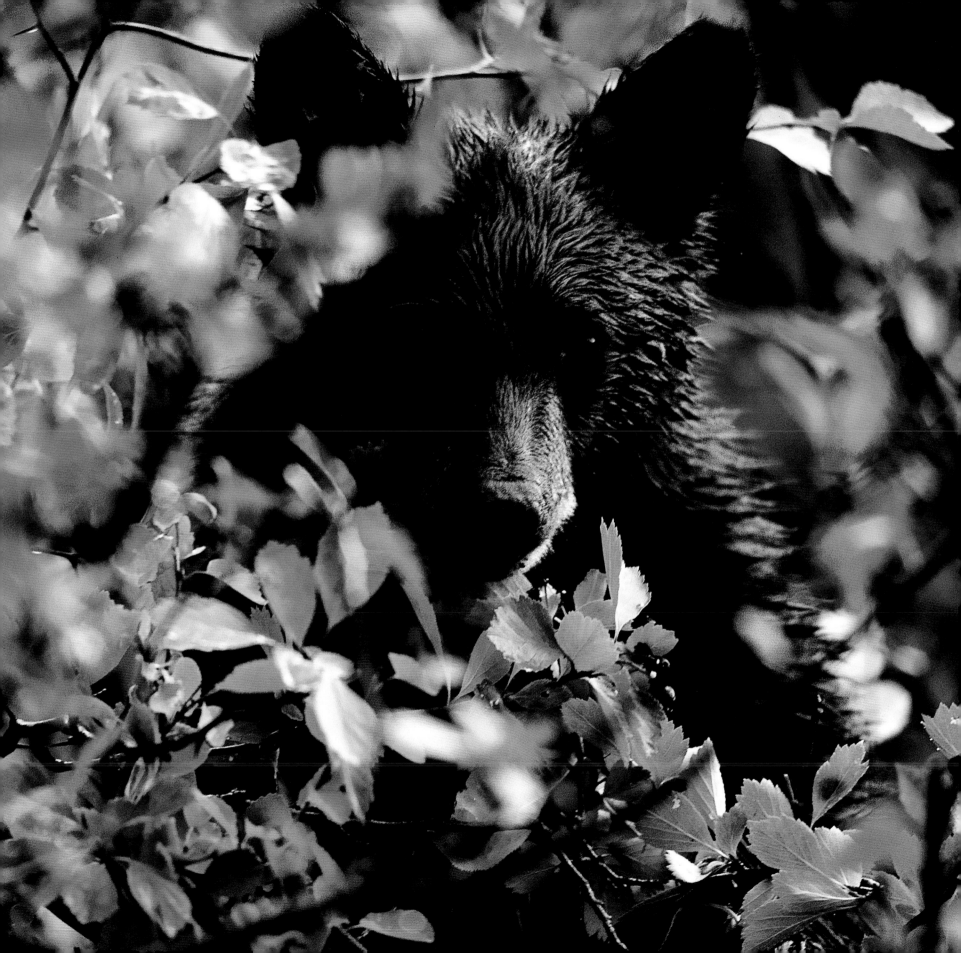

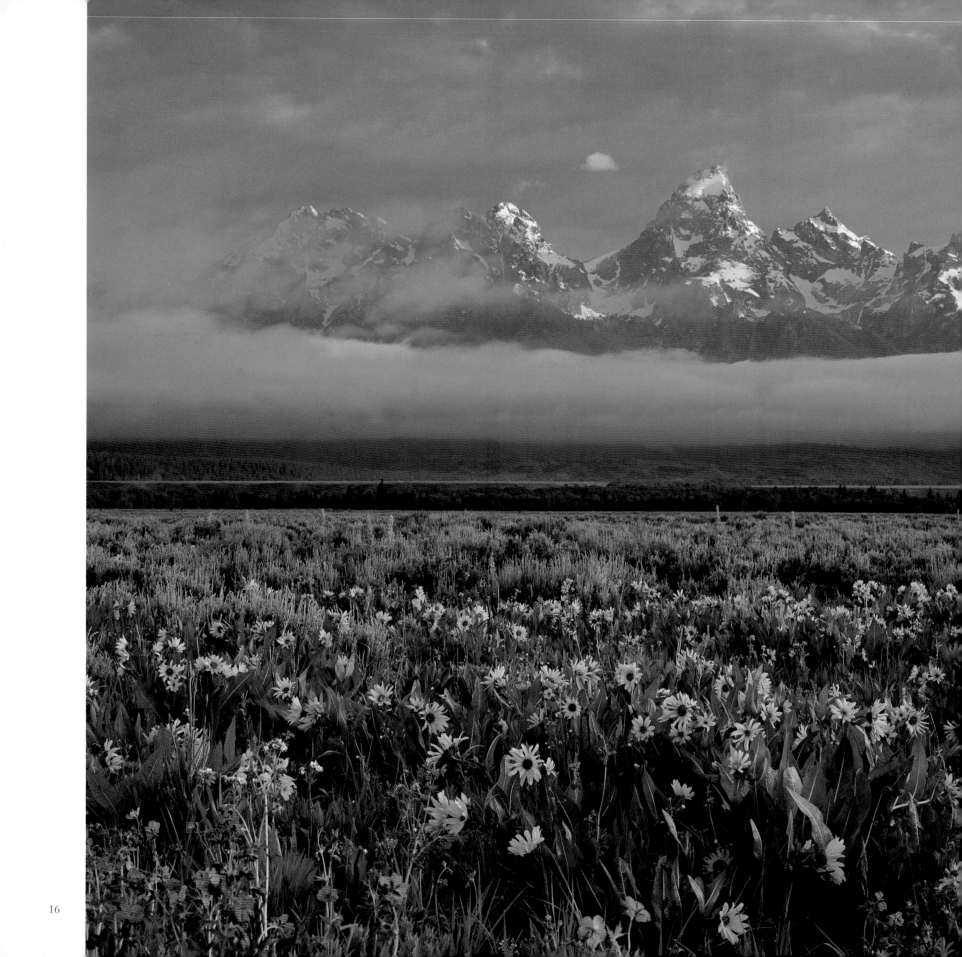

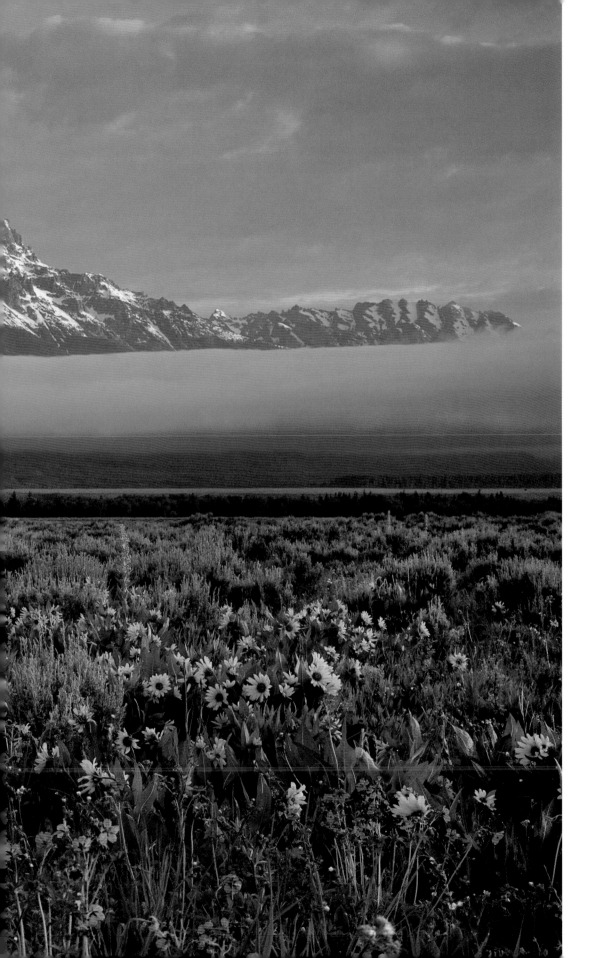

Dawn and a clearing storm on Father's Day bring a fresh carpet of flowers to the valley floor near Mormon Row in Grand Teton National Park. The park was established in 1929 and expanded in 1950 because of the efforts of industrialist and philanthropist John D. Rockefeller, Jr., and local conservationists who wanted to preserve this magnificent area for future generations. This conservation ethic is alive and well in Jackson today.

17

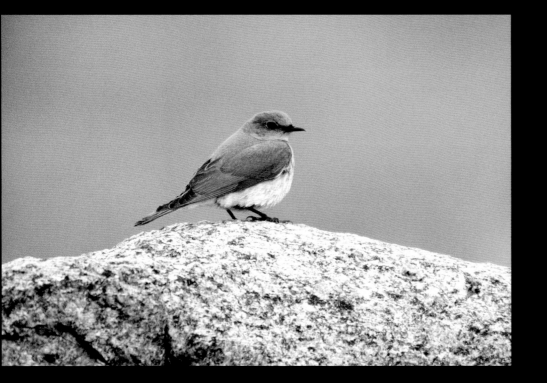

Above: A male mountain bluebird, one of the first birds to return to the valley each year, heralds the return of spring.

Right: For a bird's-eye view of Jackson (the town) and Jackson Hole (the valley), take the chairlift ride to the top of Snow King Mountain. Early trappers called a valley surrounded on all sides by mountains a "hole," and this was trapper Davey Jackson's Hole in the early 1820s. Later, the name was shortened to Jackson Hole.

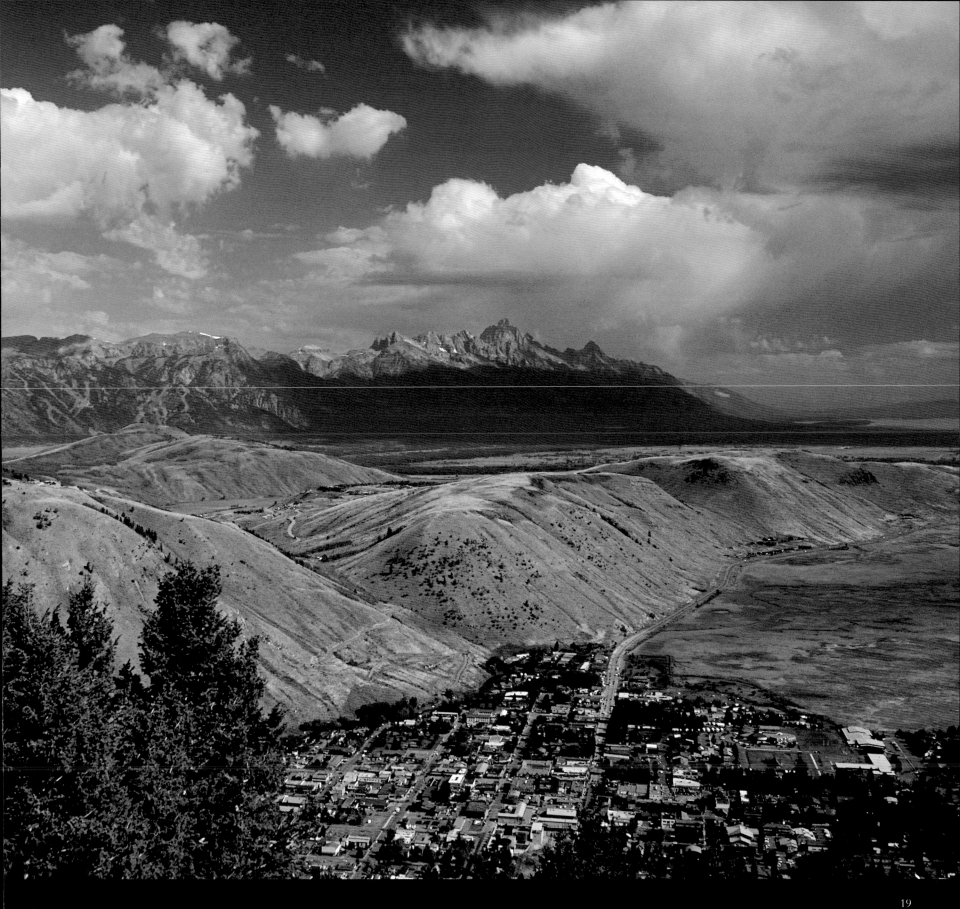

Right: Some of the Jackson Hole bison herd graze on native grasses at Antelope Flats. From a herd of 21 animals that were kept in a pasture near Oxbow Bend in the 1950s, the herd has today grown to more than 1,000 animals.

Below: A bald eagle feeds a breakfast of trout to her week-old chick high above the waters of the Snake River.

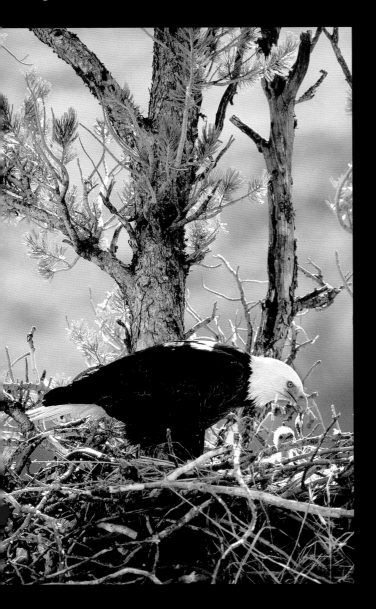

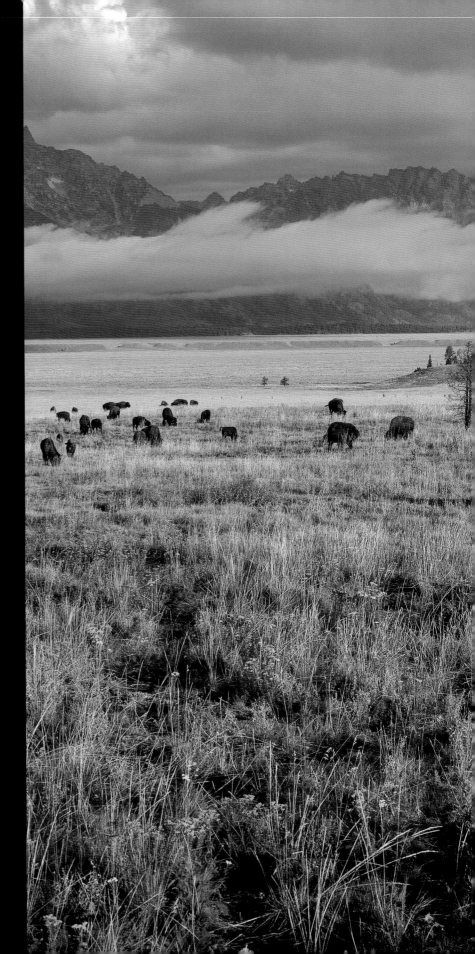

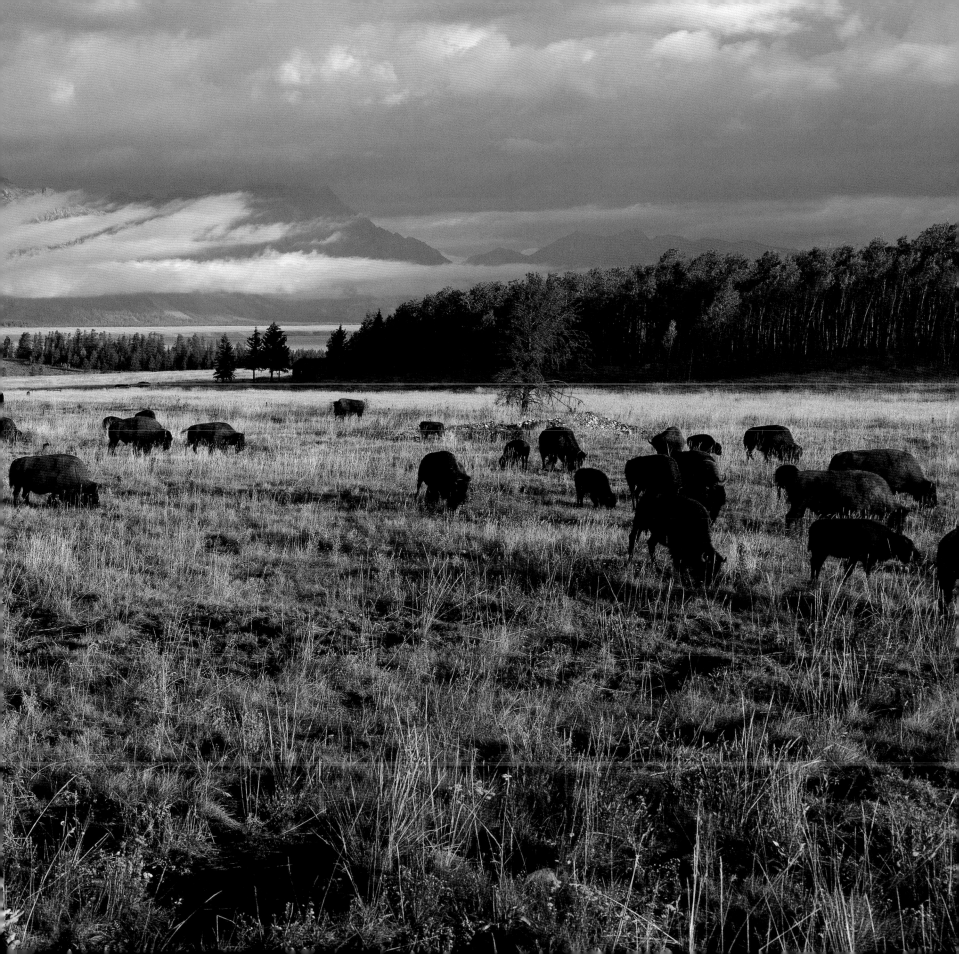

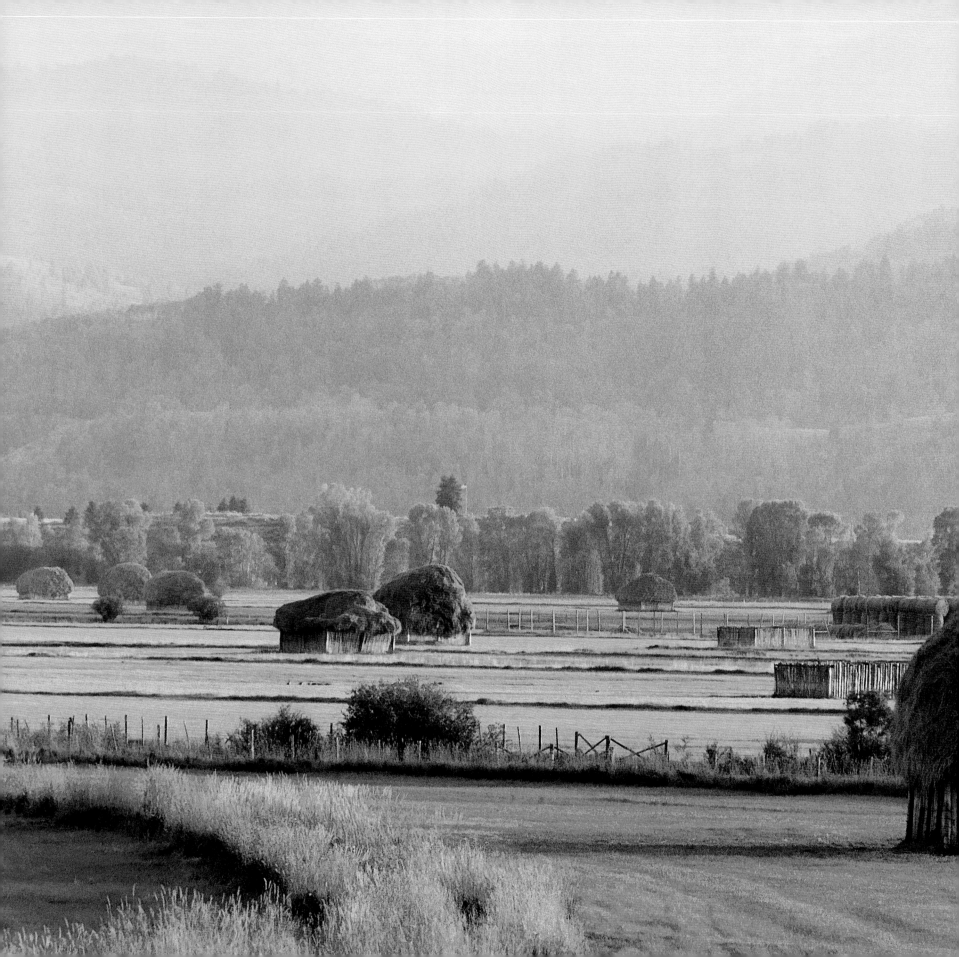

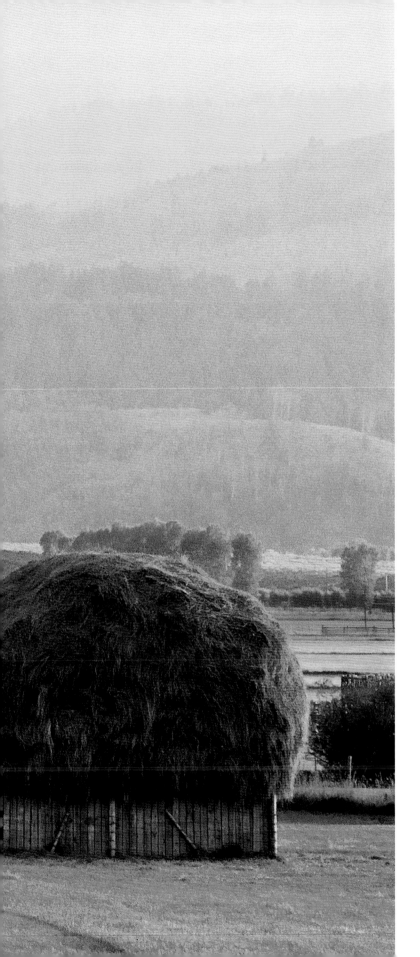

Left: The smoke from nearby forest fires lends a painterly quality to this view of haystacks on the Jackson Hole Hereford Ranch at the foot of the Snake River Range.

Below, top: A red fox kit practices pouncing in a pasture near Wilson.

Below, bottom: The rarely seen, nocturnal pine marten—a member of the weasel family—spends much of its life among the pine trees.

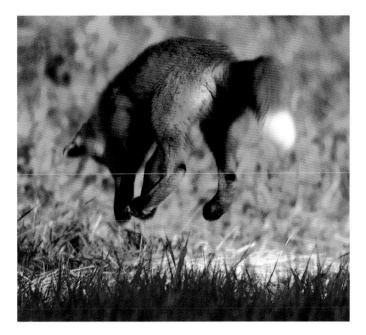

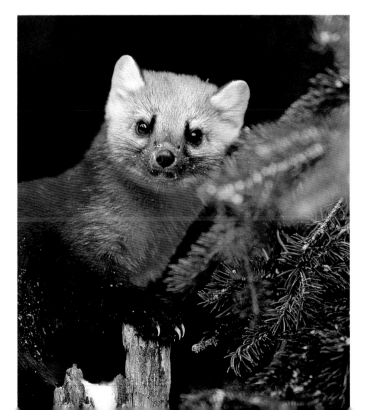

23

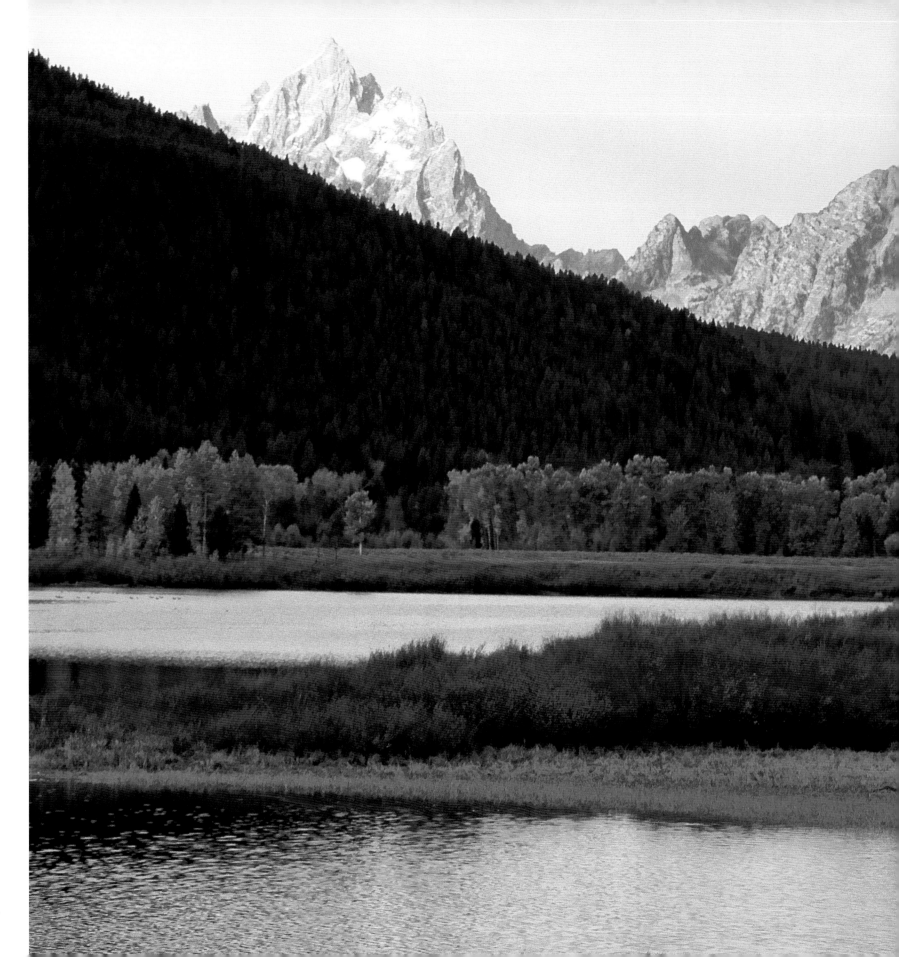

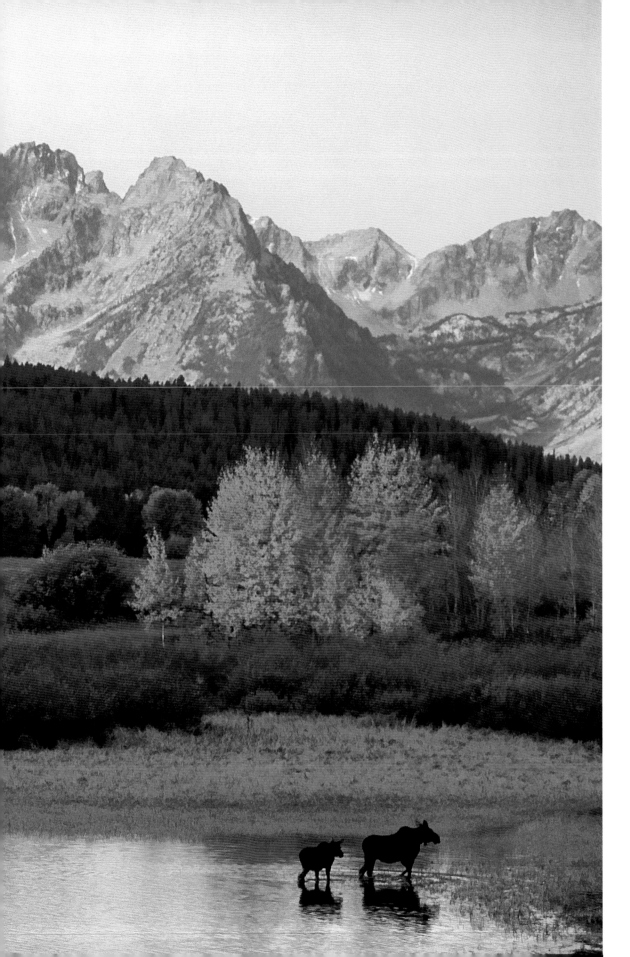

A cow moose and calf wade across the shallows of the Snake River's Oxbow Bend, a wide spot in the river that is a great place for seeing wildlife.

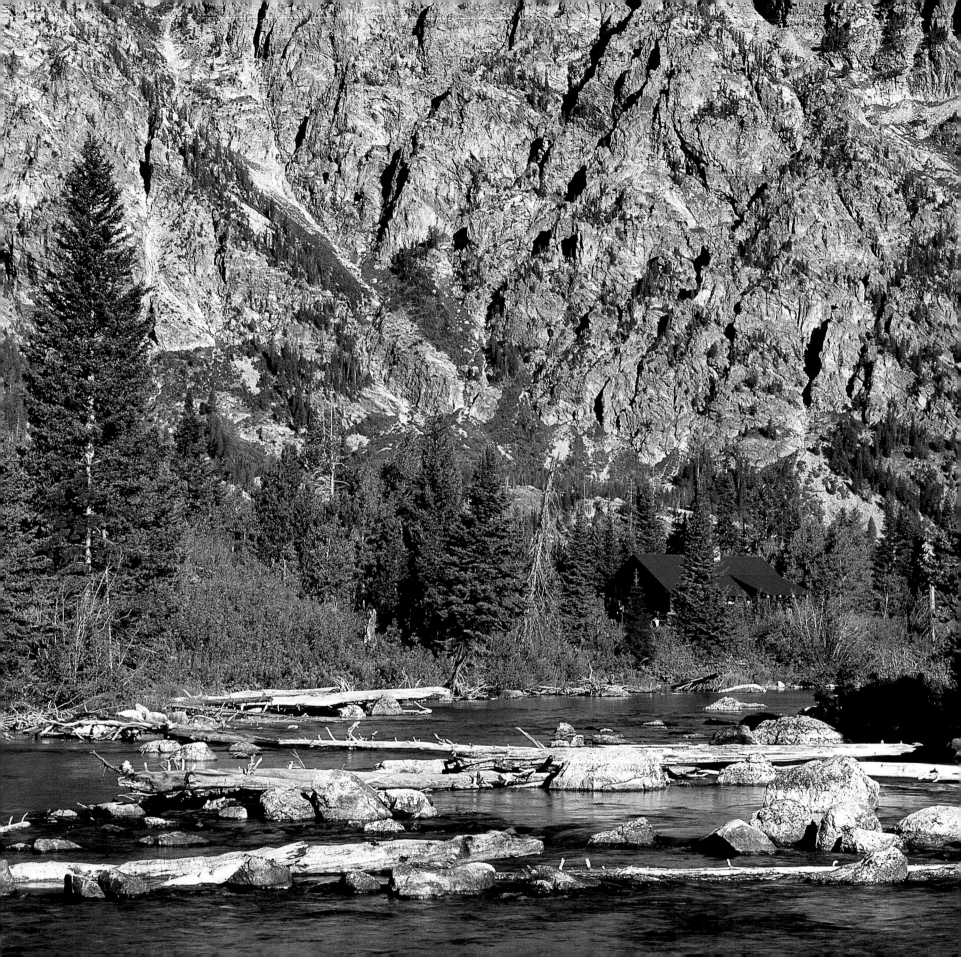

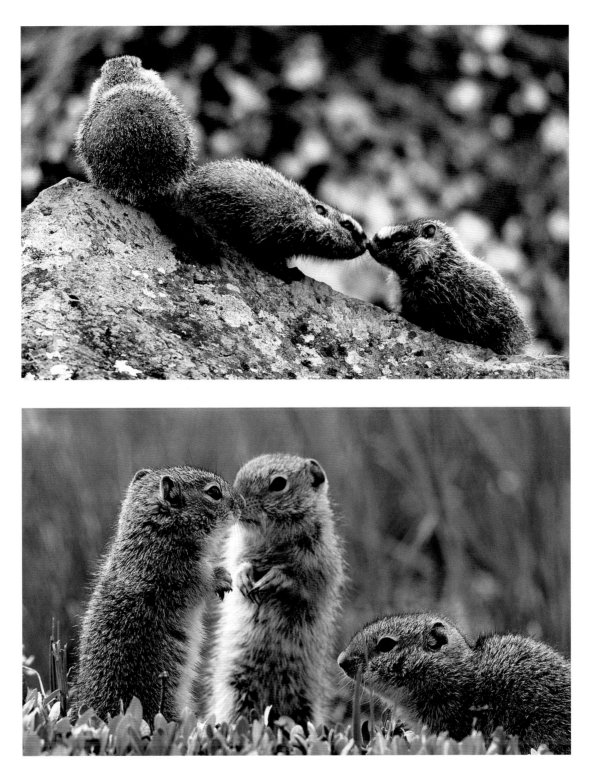

Above, top: Yellow-bellied marmot youngsters emerge from the den in late May or early June.

Above, bottom: Plentiful Uinta ground squirrels, known locally as chisellers, spend much of their time playing.

Facing page: Peaceful Cottonwood Creek flows out of the south end of Jenny Lake.

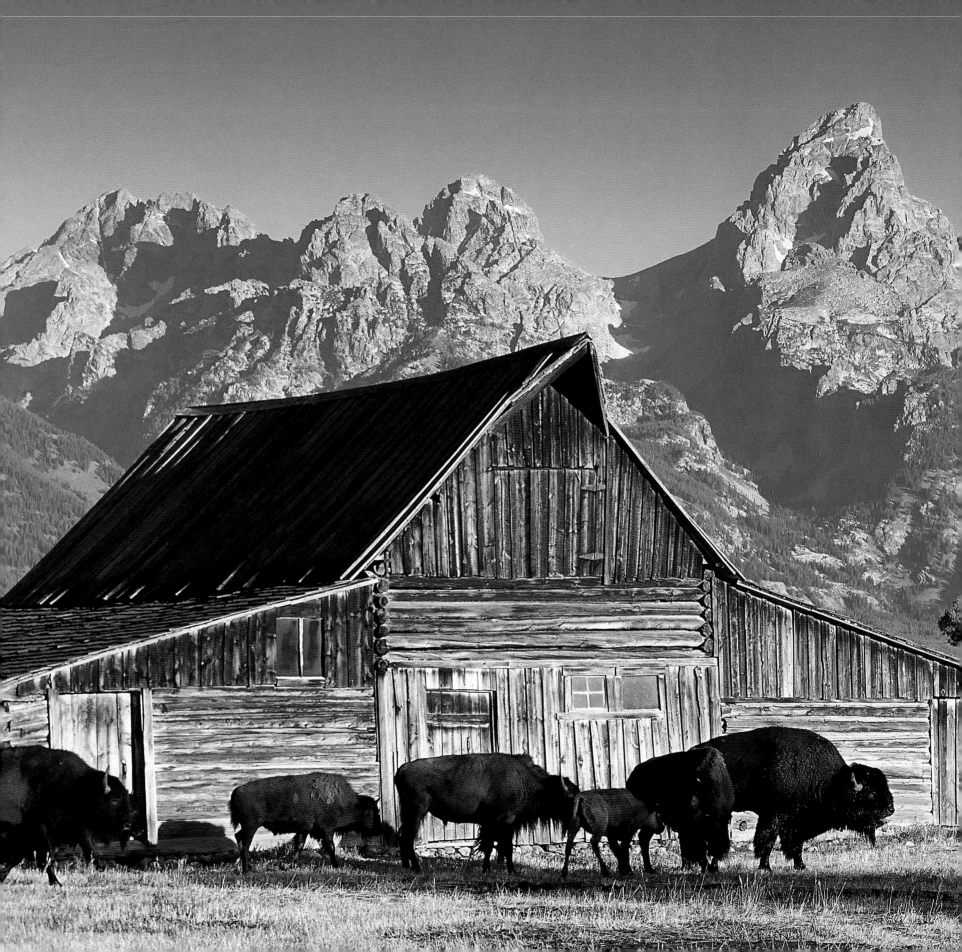

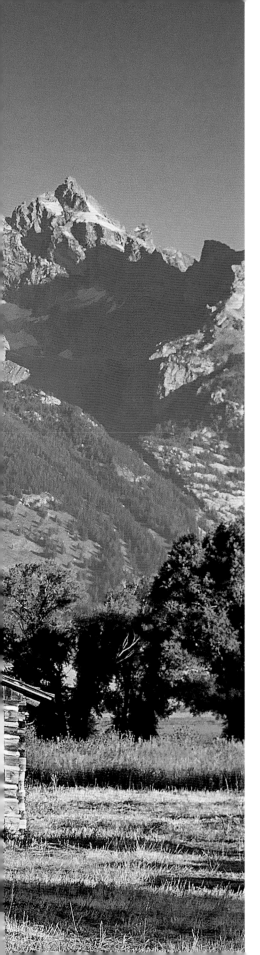

Left: Bison wander past the Moulton Barn in Grand Teton National Park.

Below: Aspen trees find adequate moisture in the sheltered drainages of the aptly named Red Hills, located in the Gros Ventre Range east of Kelly.

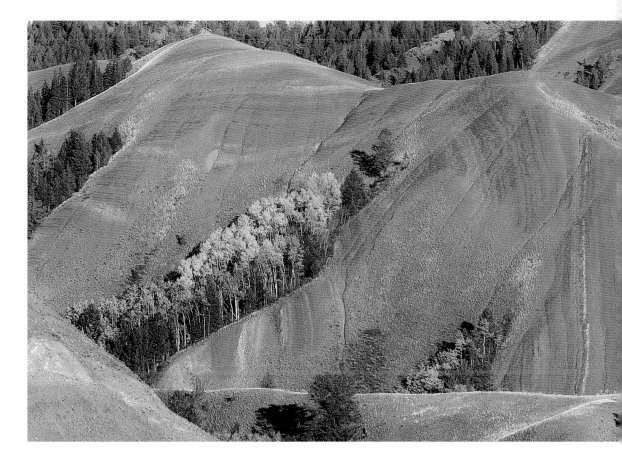

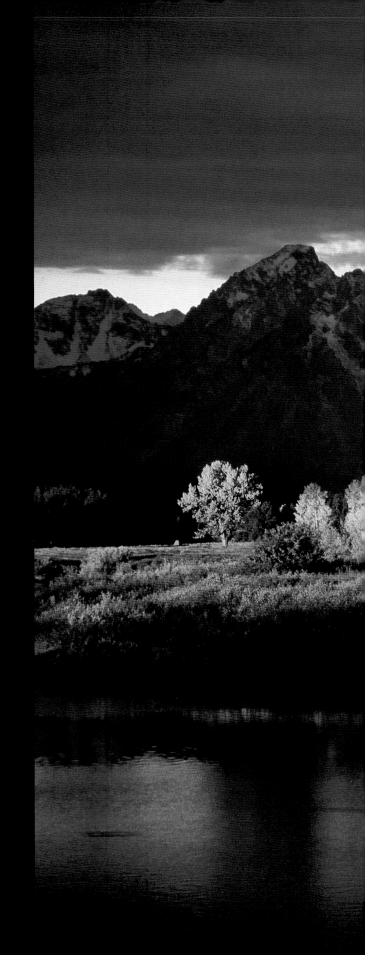

Right: Aspen trees in fall color receive the day's first light in the wake of a September storm that dusts Mount Moran with snow.

Below: In spring, a male cinnamon teal sports bright red breeding plumage.

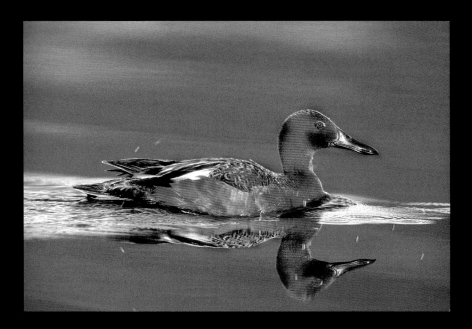

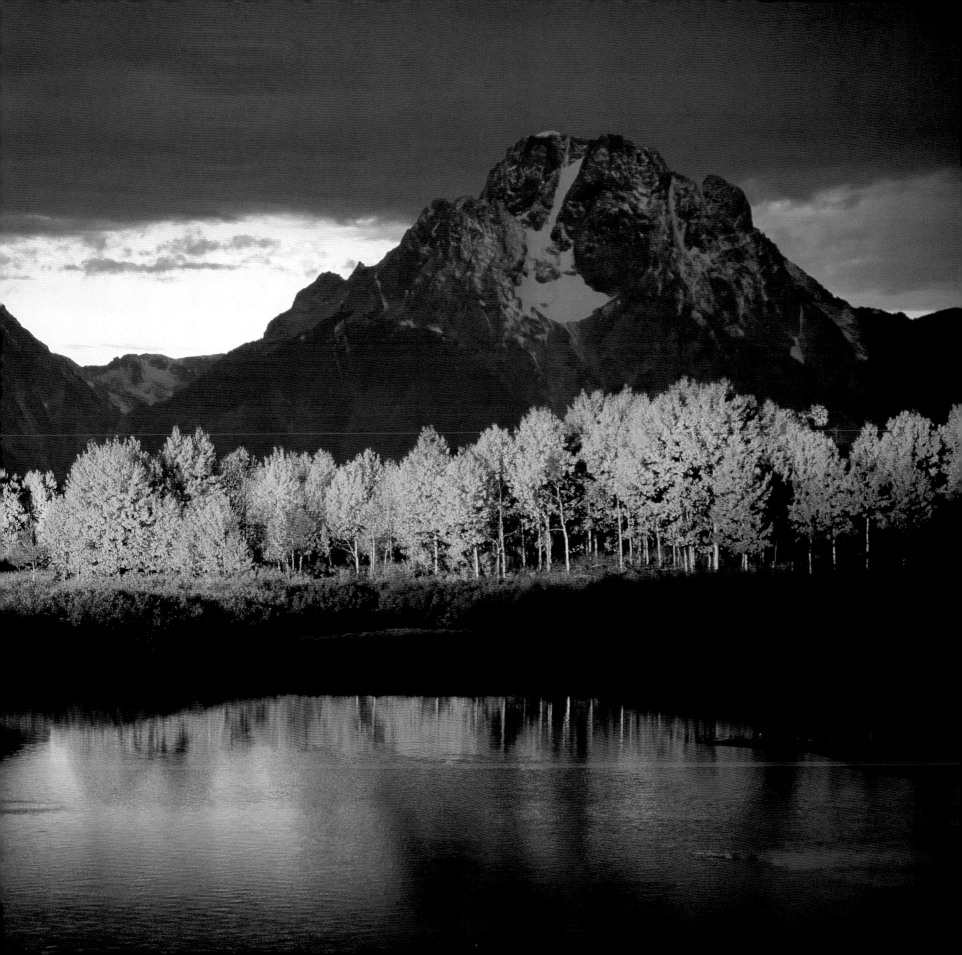

Below and right: Competitors lasso fleeing calves and ride bucking broncs in the Jackson Hole Rodeo. PHOTOS BY BOB WOODALL/FOCUSPRODUCTIONS.COM

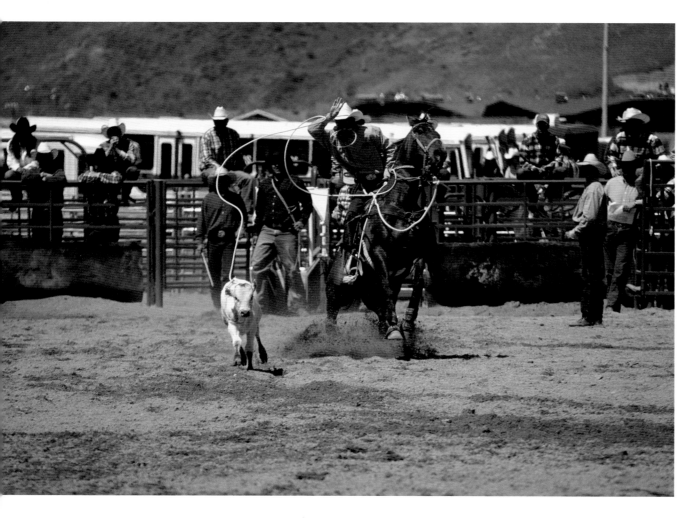

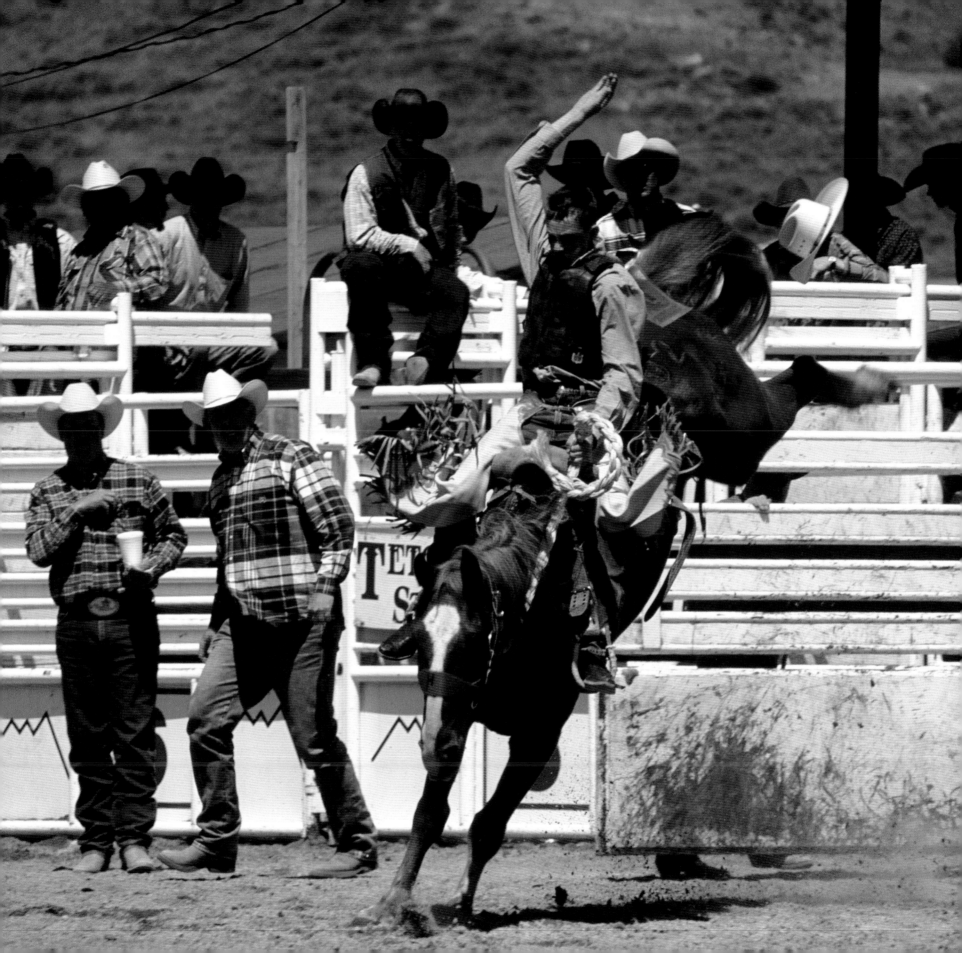

Right: The String Lake Bridge provides access to many popular hiking trails in the park.

Below: A pair of trumpeter swans keep a close watch on their two-week-old cygnet. These rare birds mate for life and return, year after year, to the same pond to nest.

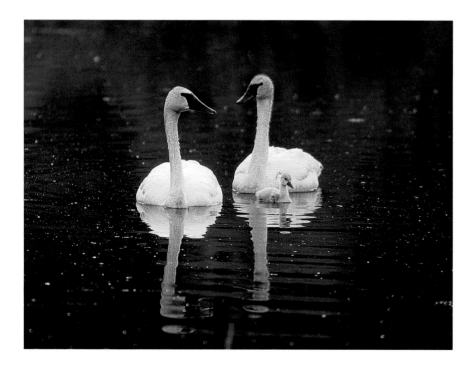

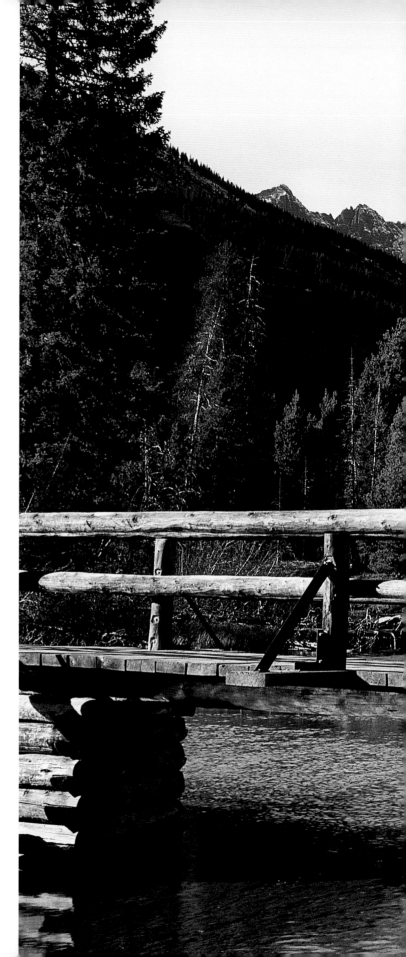

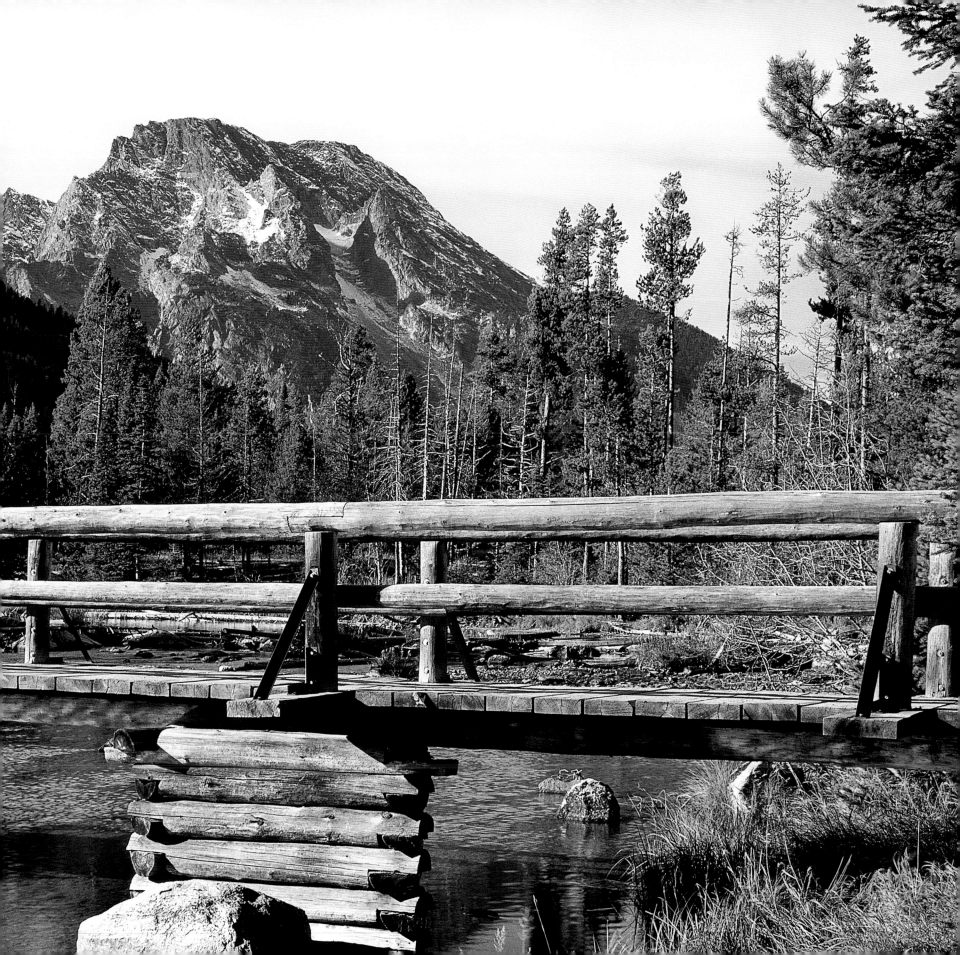

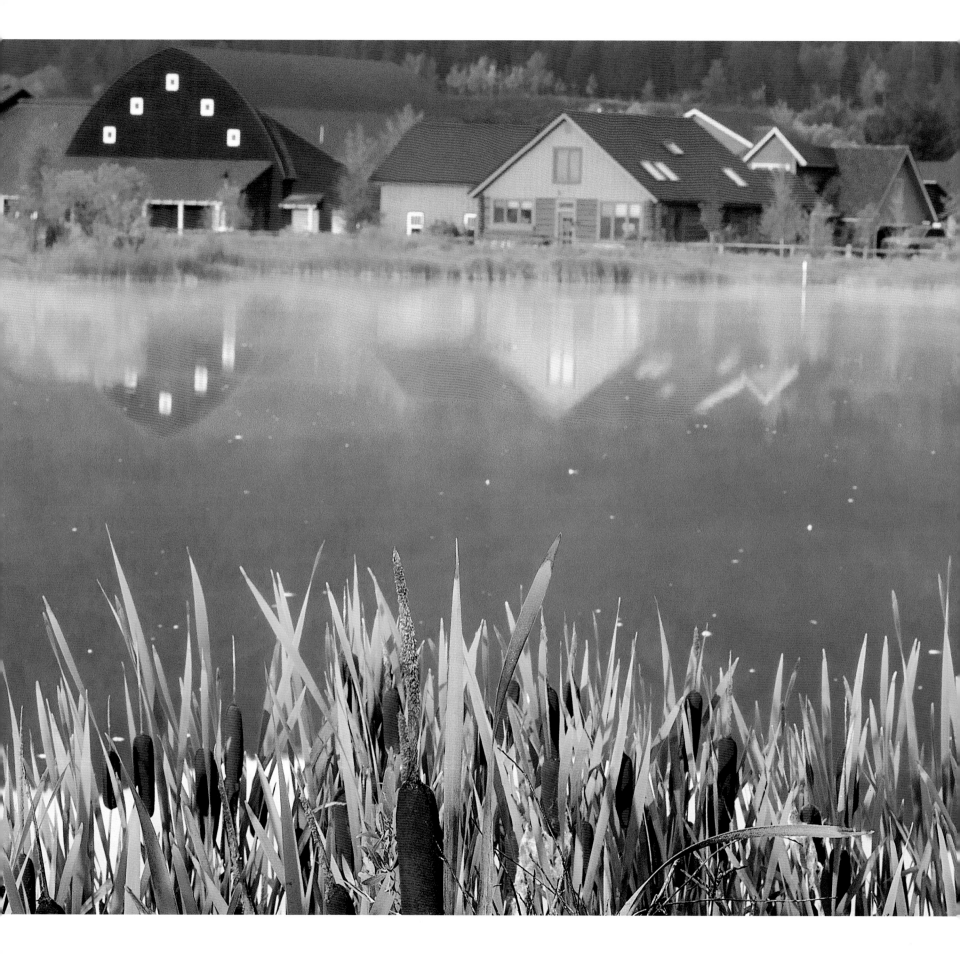

Left, top: This little sunflower brightens the trail to Death Canyon.

Left, bottom: Wyoming paintbrush, the state's official flower, is also known as Indian paintbrush. There are a dozen different species of paintbrush in the valley.

Facing page: The view of Wilson School and neighboring homes is from a pond in Hardeman Meadows, once part of the old Hardeman Ranch.

Facing page: Backpackers begin to climb up scenic Fox Creek Pass, on the park's western boundary. A trip to the backcountry is the one of the best experiences Jackson Hole has to offer.

Below: The historic Manges Cabin on Beaver Creek is dwarfed by the summits of Mount Teewinot and Mount Owen. James Manges, who homesteaded the property in 1911, used to leave a note tacked to his door if he was out that read: "Gone fishing. If I don't come back, try to make a living off the place."

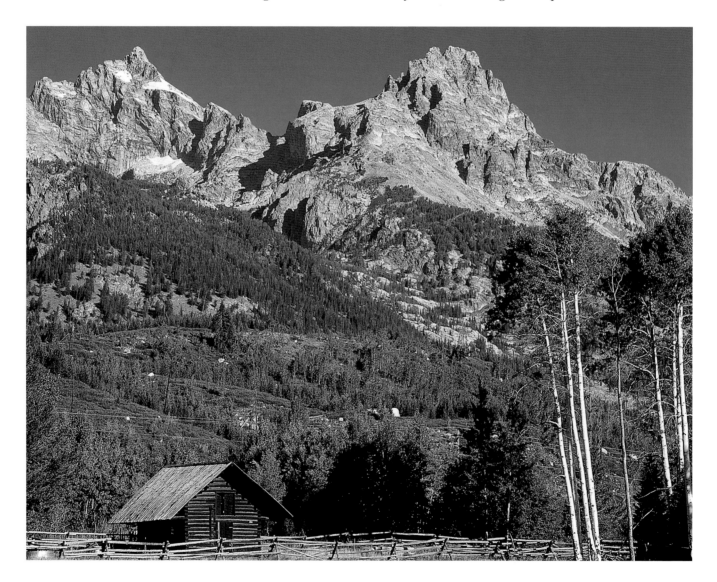

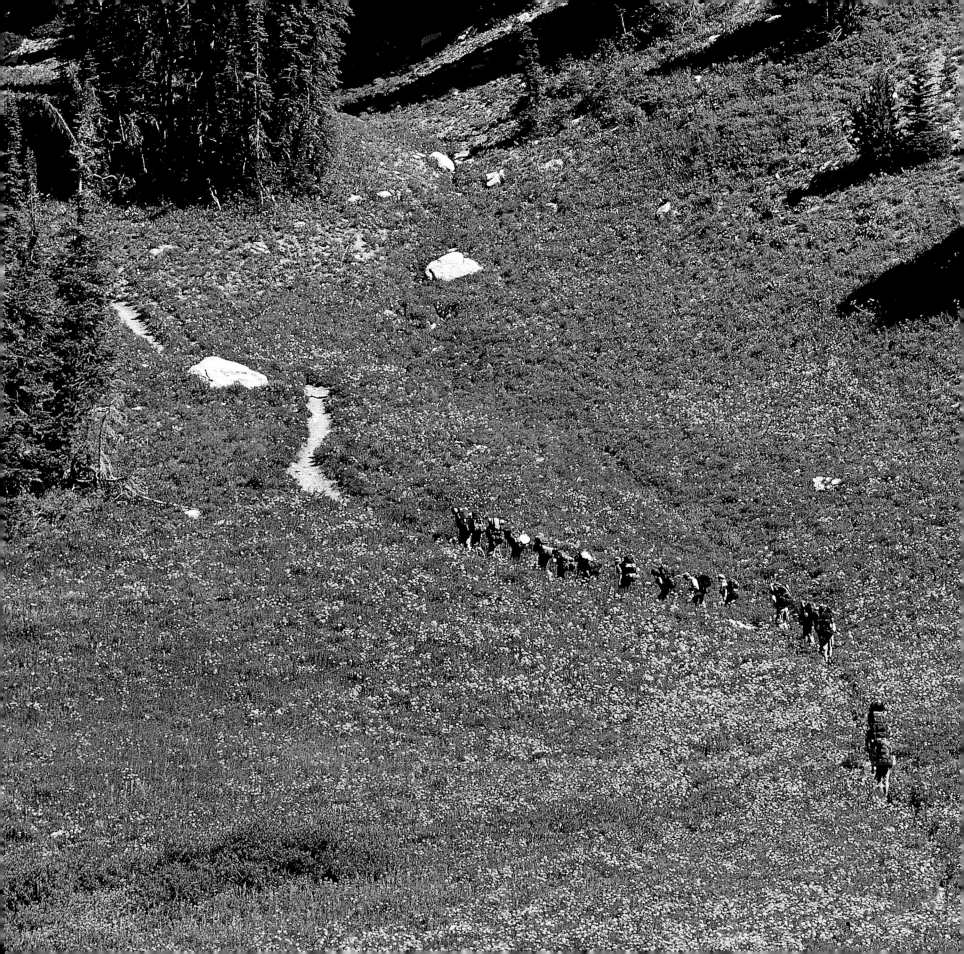

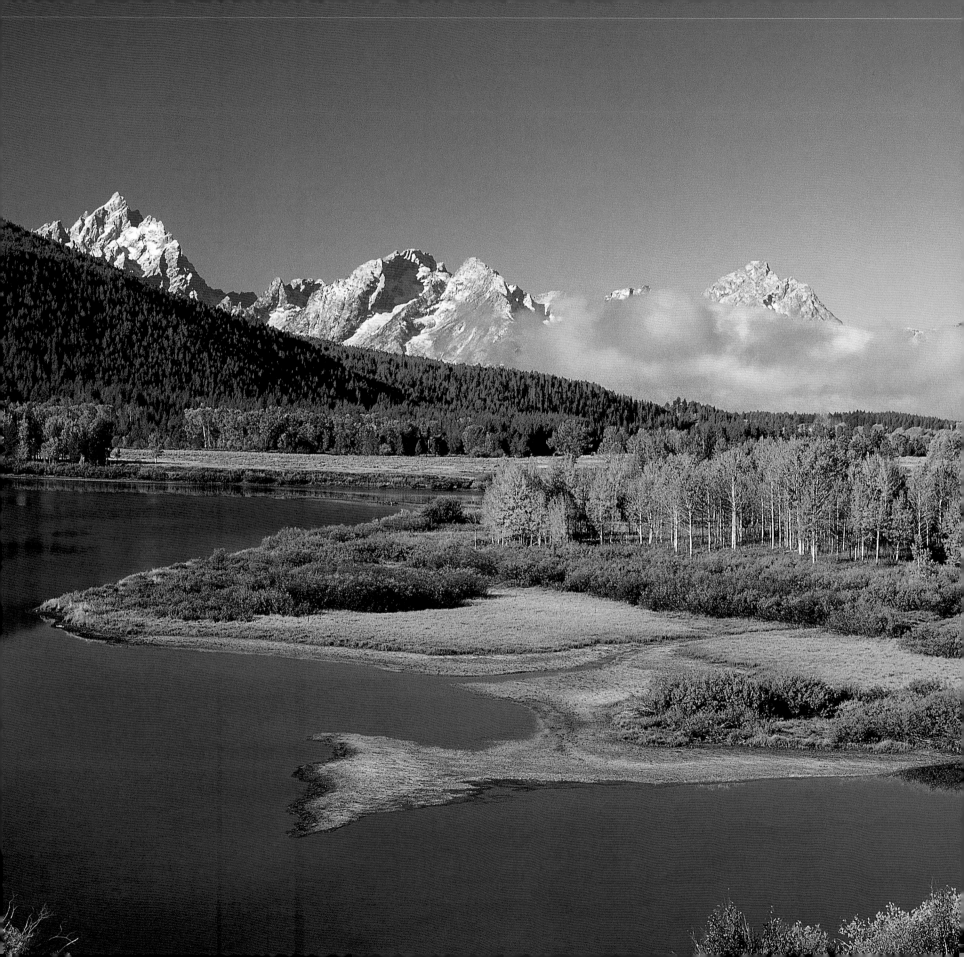

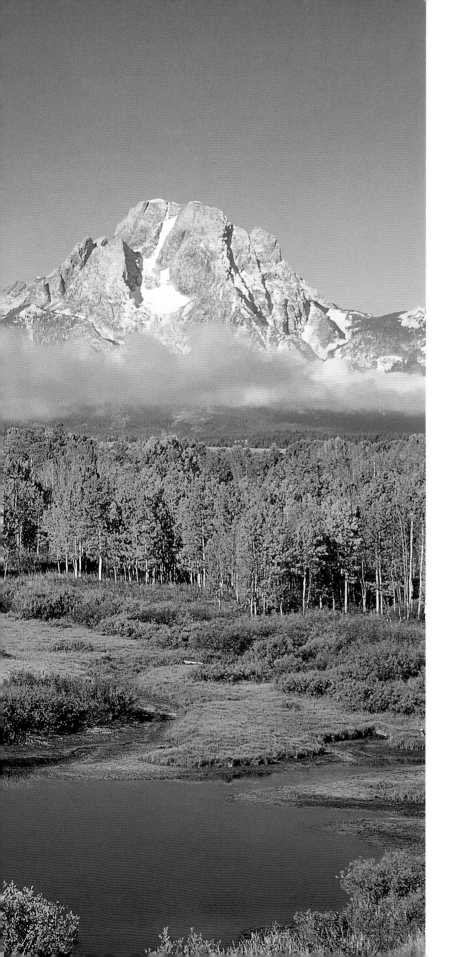

Left: The Teton Range rises above Oxbow Bend, with a fresh dusting of snow on its flanks.

Below: All dolled up with no place to go: this colorful pair of coot chicks will grow into plain black water birds.

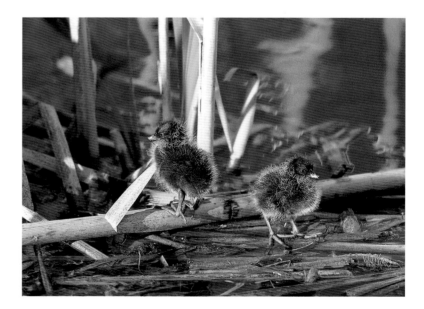

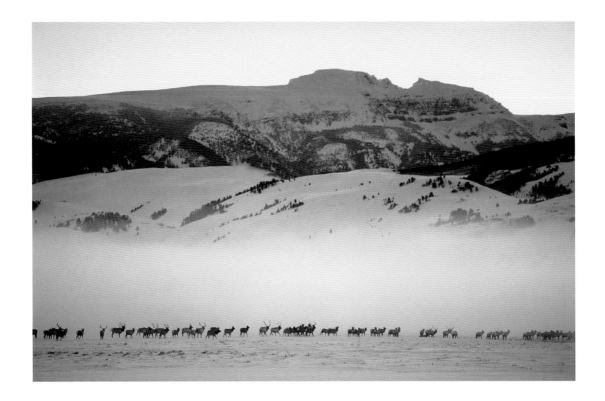

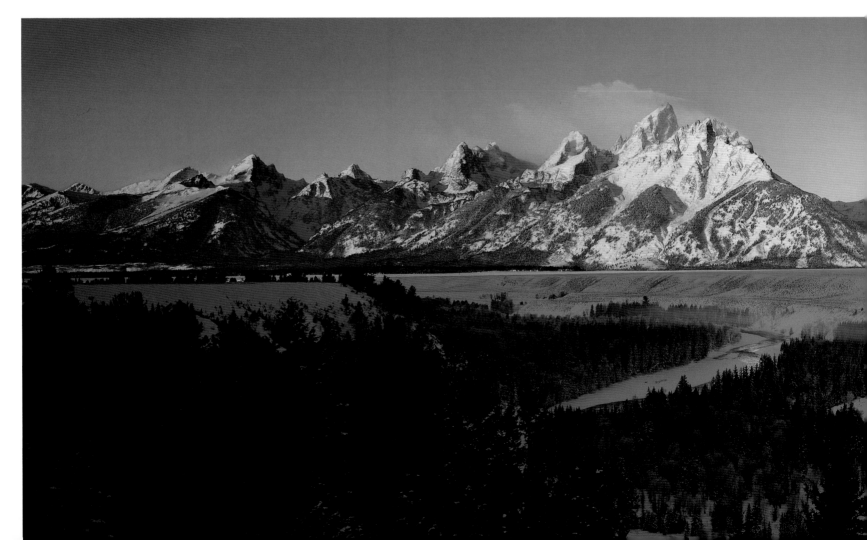

Left: The National Museum of Wildlife Art has 12 galleries and 15,000 square feet of exhibit space dedicated to an internationally acclaimed collection of more than 3,000 works, including paintings, sculpture, and photography.

Facing page: The National Museum of Wildlife Art offers an outstanding view of the elk on the National Elk Refuge and, in the background, the Sleeping Indian.

Below: The Teton Range stretches out on a 25-below-zero morning at the Snake River Overlook. This mighty river meanders down the middle of the valley, following glacial routes left tens of thousands of years ago.

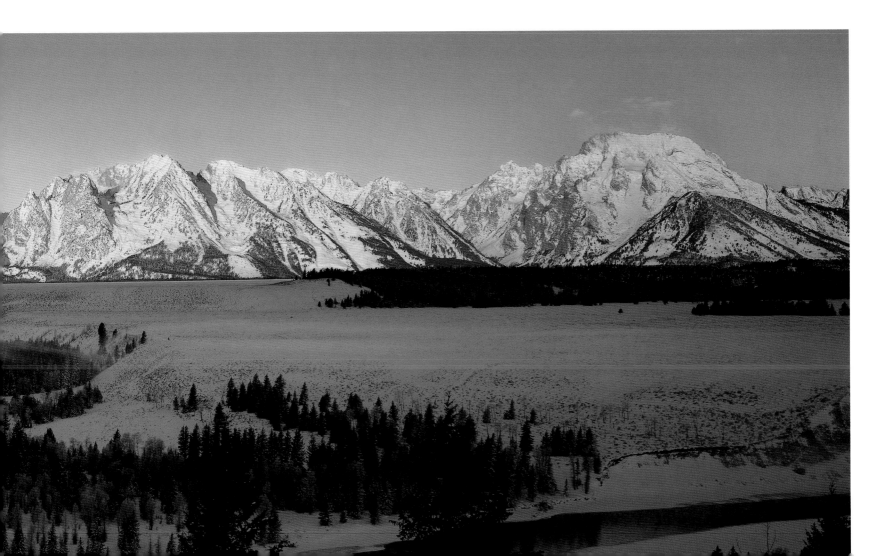

Right: Fresh snow highlights the Tetons' tallest peaks, known as the Cathedral Group. In this view from Old Patriarch Tree in Grand Teton National Park, some of these peaks include, from the left, 12,325-foot Teewinot Mountain, 13,770-foot Grand Teton, and 12,928-foot Mount Owen.

Below: A female mountain lion watches as her cubs play below their winter den on Miller Butte in the National Elk Refuge. During heavy snow years, cougars may track game from the mountains all the way to the valley floor.

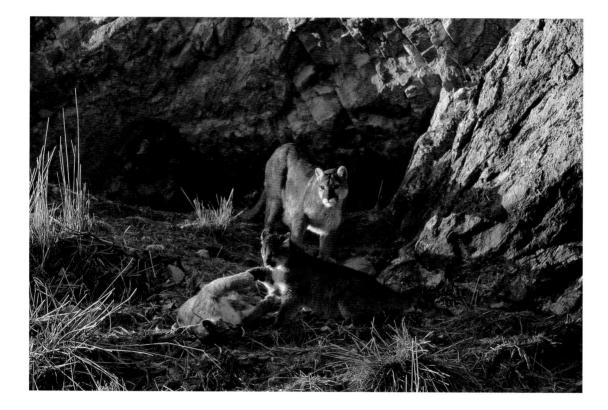

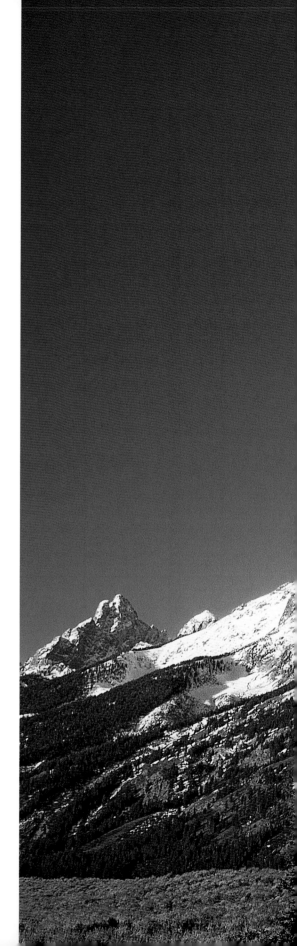

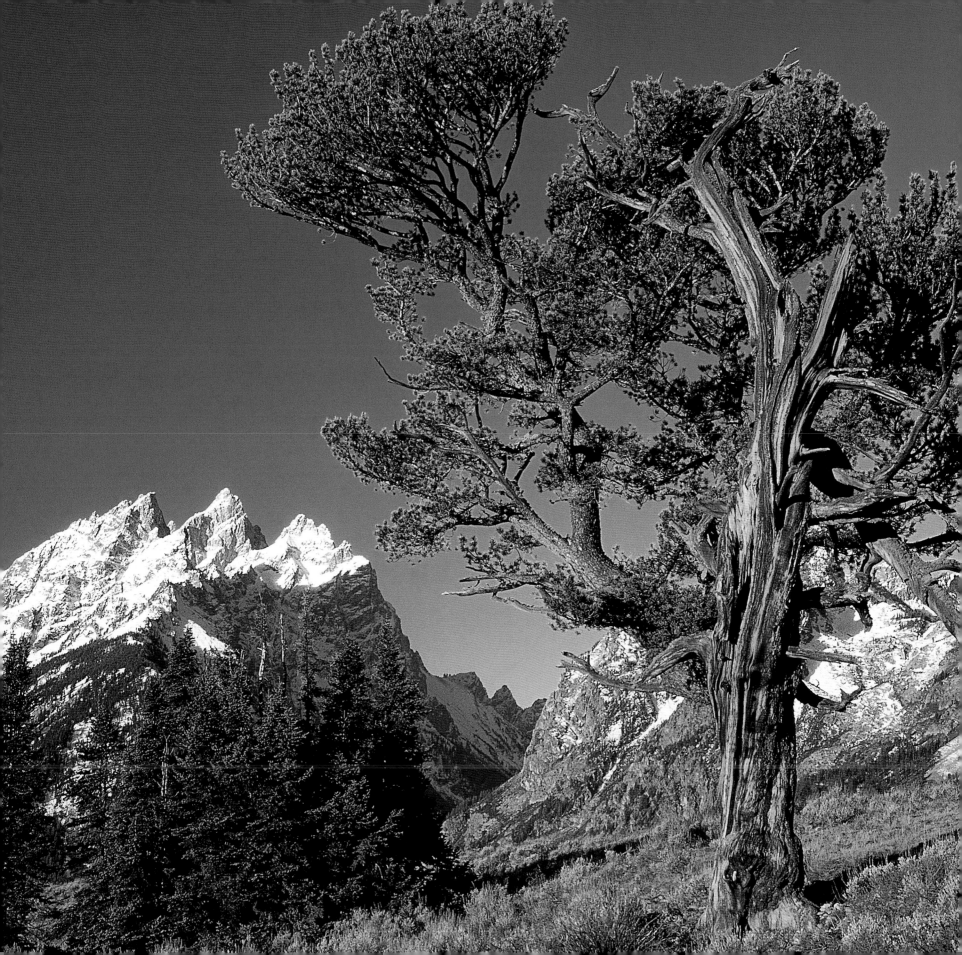

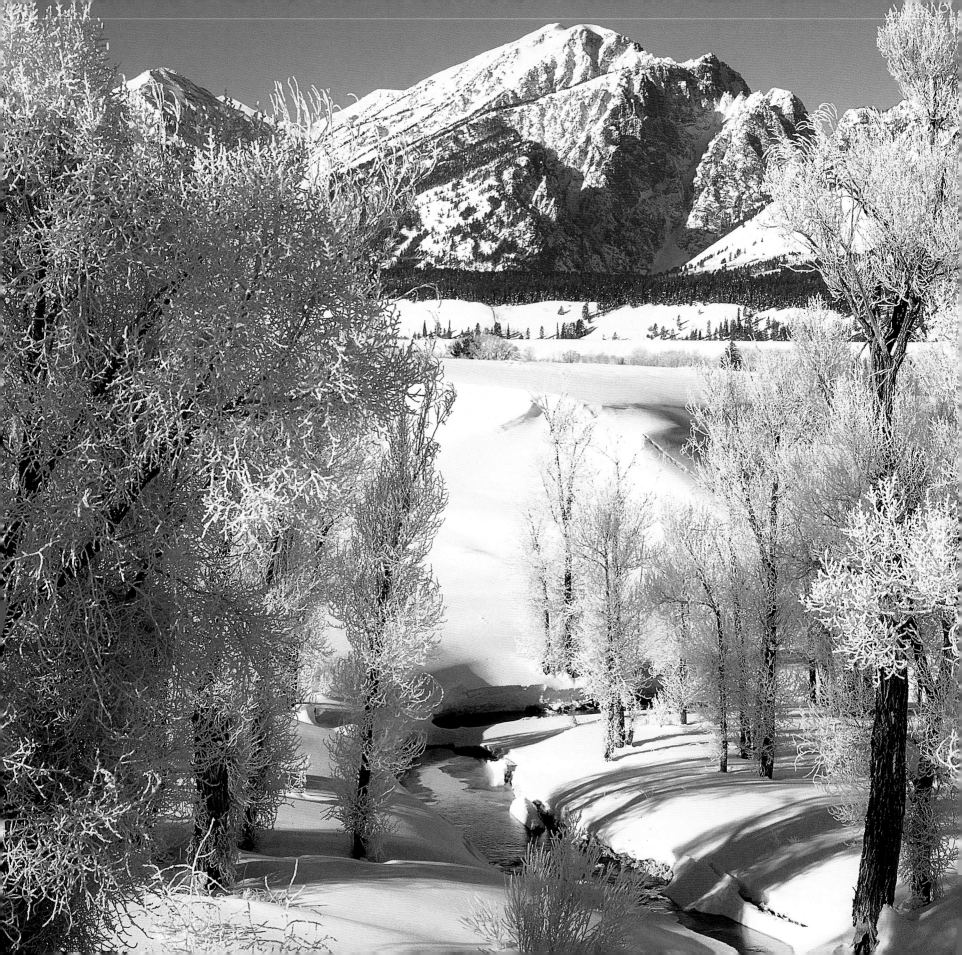

Left: Frosted cottonwoods along Ditch Creek guide the eye toward 11,217-foot Prospectors Mountain in the center and 10,783-foot Mount Hunt to the left. Below-zero nights with little or no wind cause hoar frost to coat almost any surface, making many winter mornings look dreamlike.

Below: Snowmobilers take in the view from the top of Austin Peak on the Continental Divide Snowmobile Trail near Togwotee Pass.

PHOTO BY BOB WOODALL/FOCUSPRODUCTIONS.COM

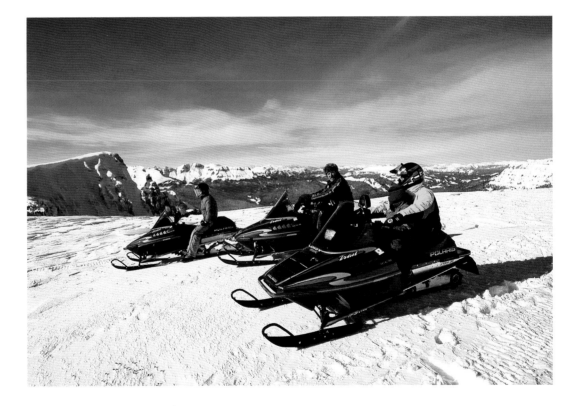

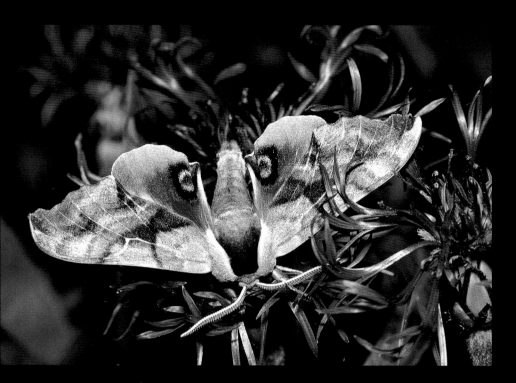

Above: A twin-spotted sphinx moth pollinates a blossom while searching for nectar.

Right: Bluish-purple lupine and golden-colored desert parsley blossoms wait for the morning sun to reach the valley floor below the Teton Range.

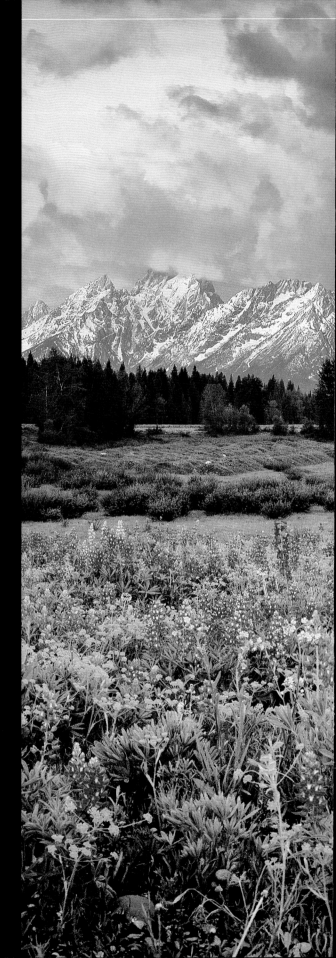

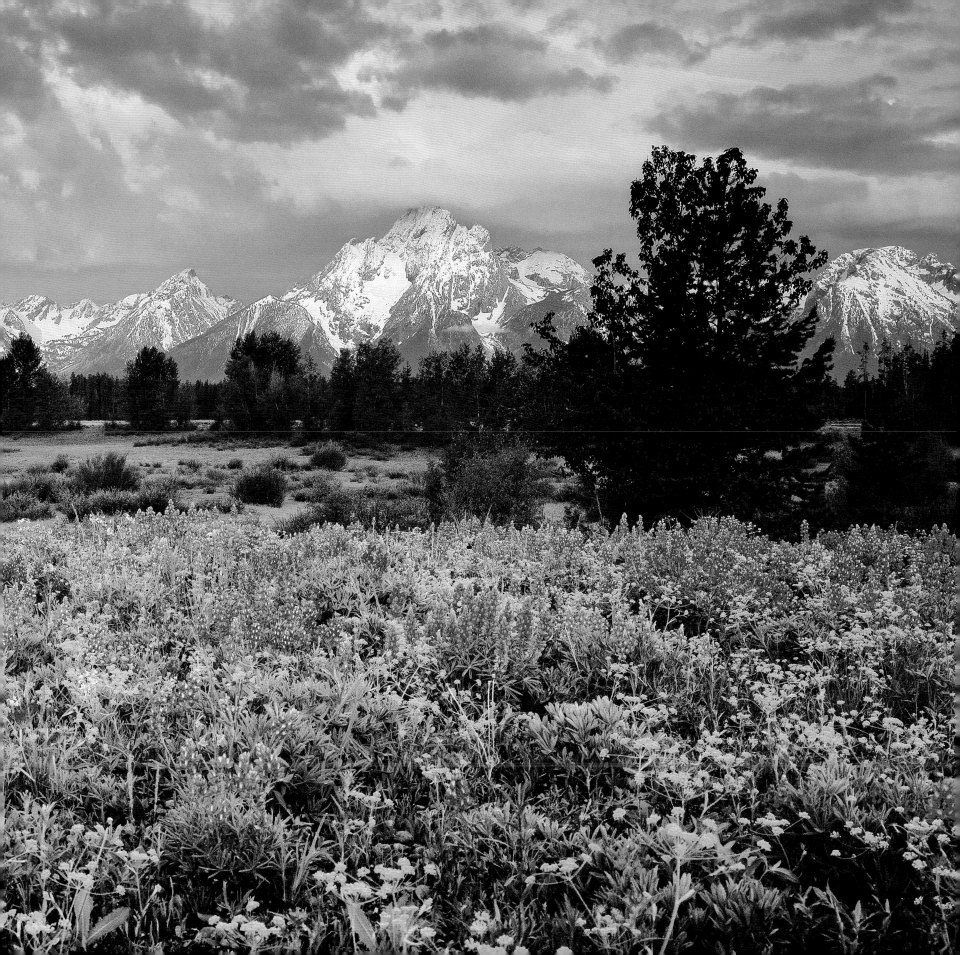

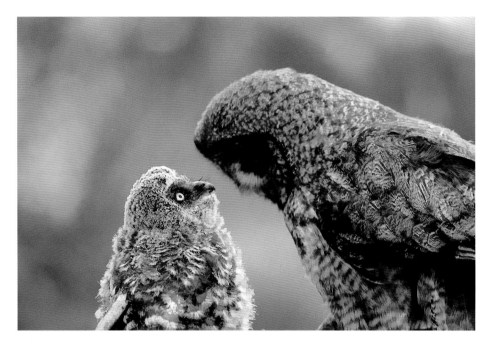

Above: Here's looking at you, kid! A great gray owl mother gets face to face with her chick. At five weeks old, it has fledged from the nest but is still unable to fly.

Right: Established in 1894, Menor's Ferry, north of Moose, was originally the only way to cross the river until a bridge was built in 1927. William D. Menor built a ferry here because it was one of the few places where the many braids of the Snake River were confined to a single channel. He charged 50 cents for a wagon and team and 25 cents for a rider and horse.

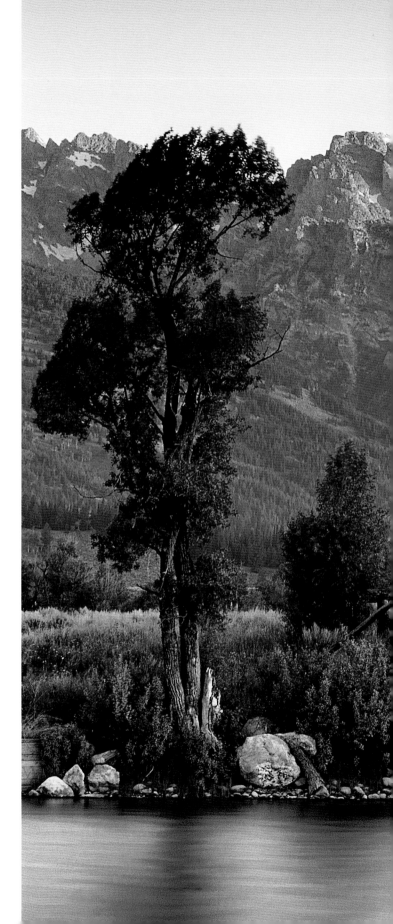

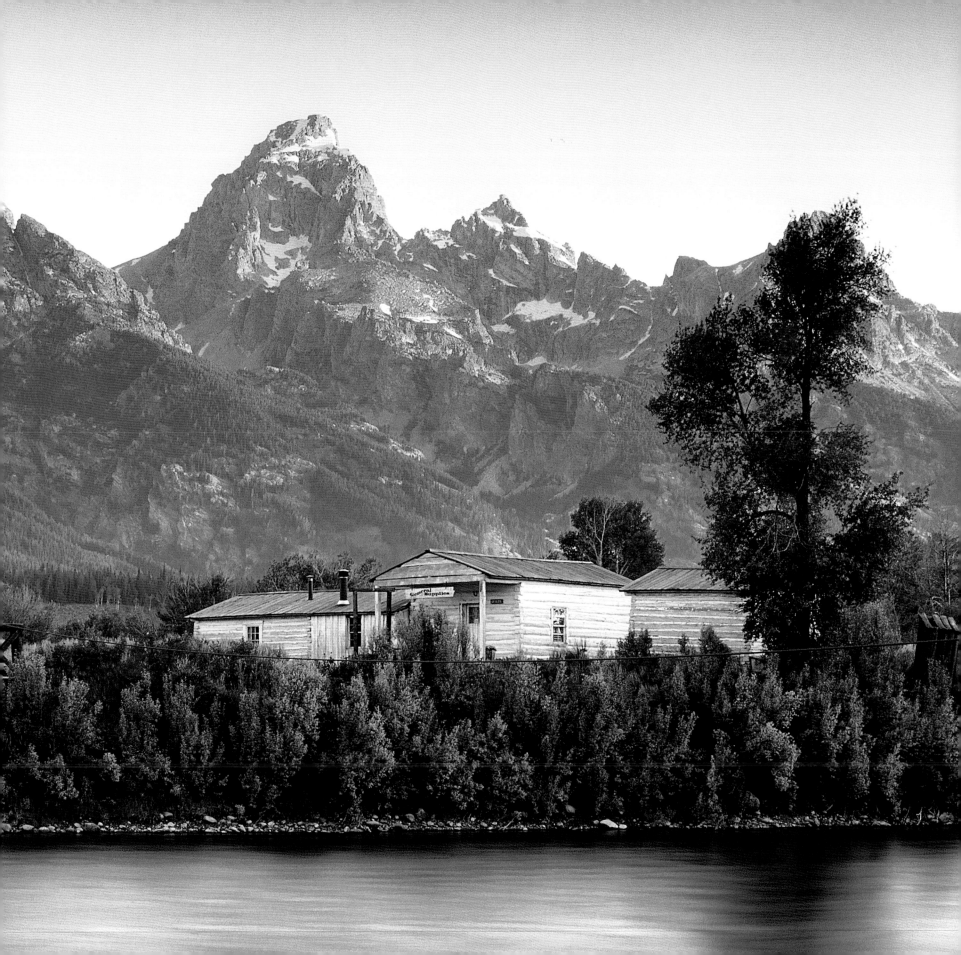

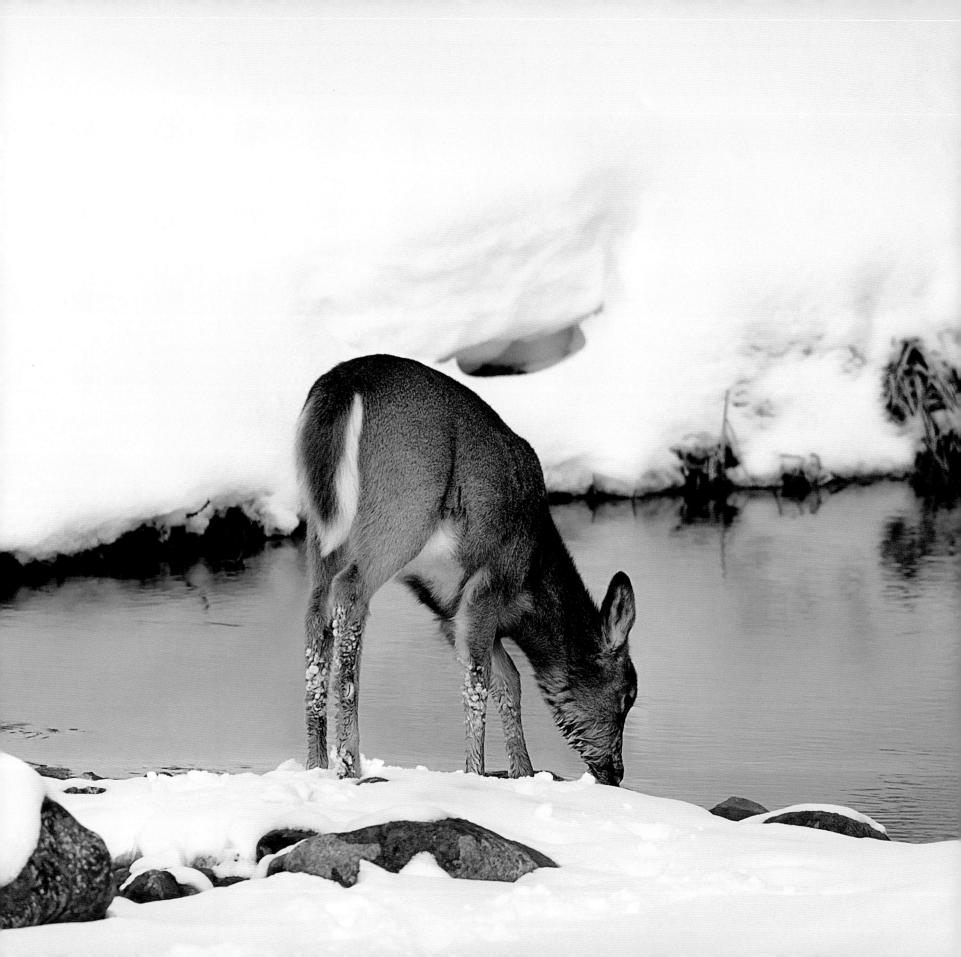

Left: A short-tailed weasel peeks out from the safety of a backyard woodpile. When the weasel's brown summer fur changes to its white winter coat, it is known as an ermine.

Far left: The first winter is cold for a white-tailed deer fawn living along Fish Creek.

Below: A mule deer doe and fawn nuzzle one another on Saddle Butte, on the west side of town.

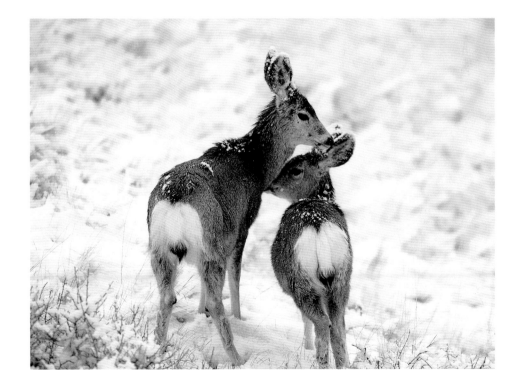

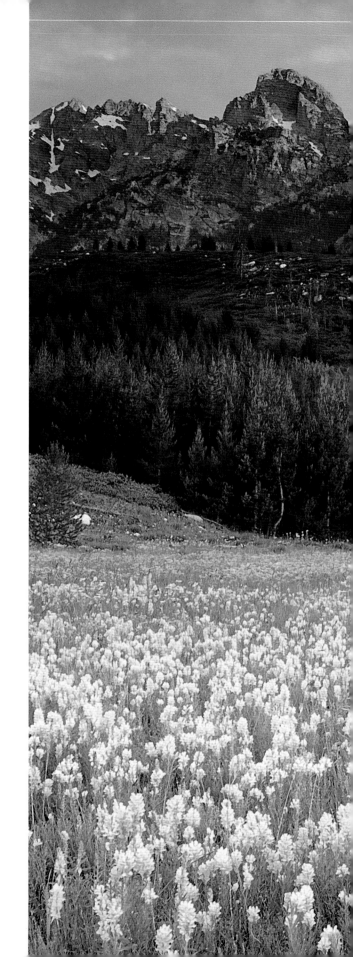

Right: A field of yellow butter-and-eggs greets the dawn along the Taggart Lake Trail.

Below: Trail riders guide their mounts along Christian Creek near Jackson Lake Lodge.

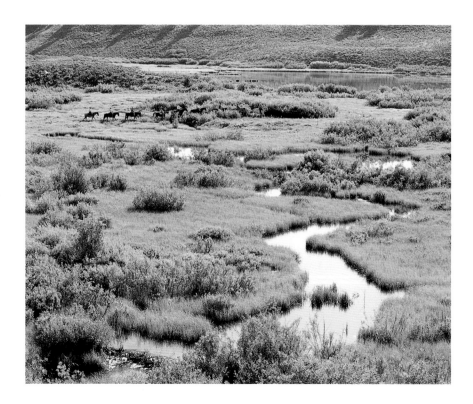

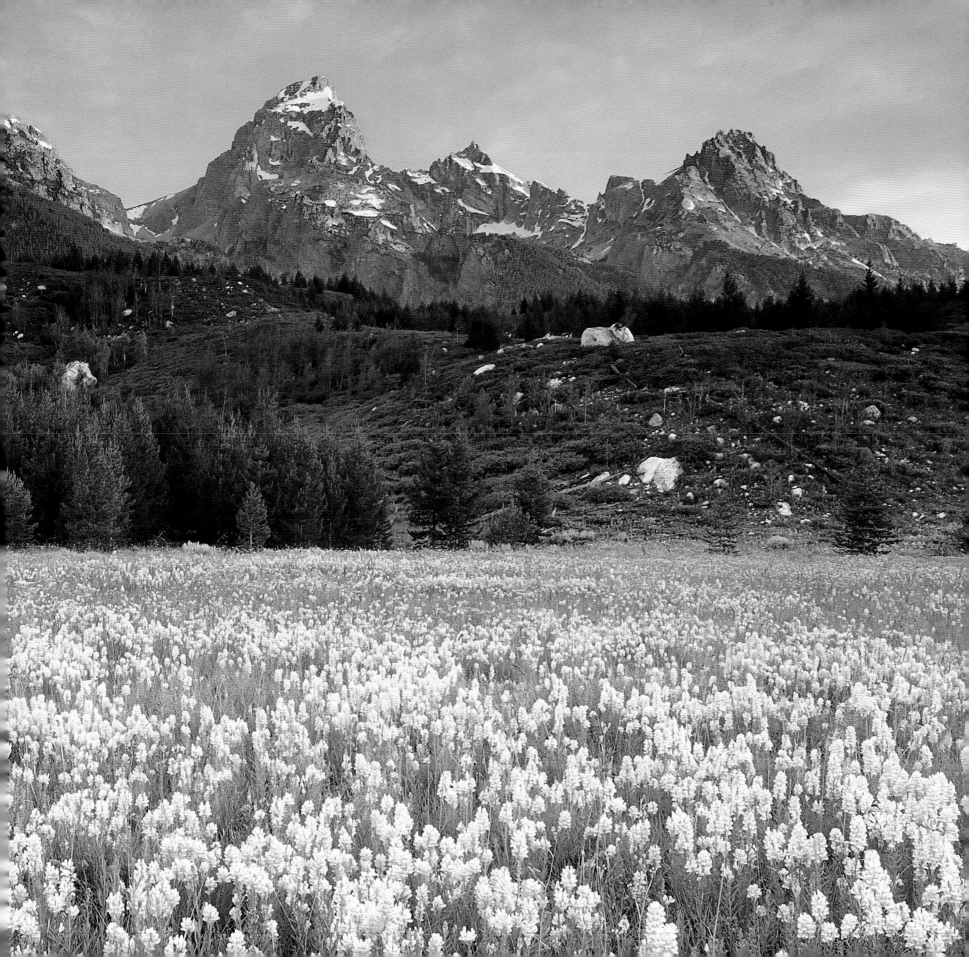

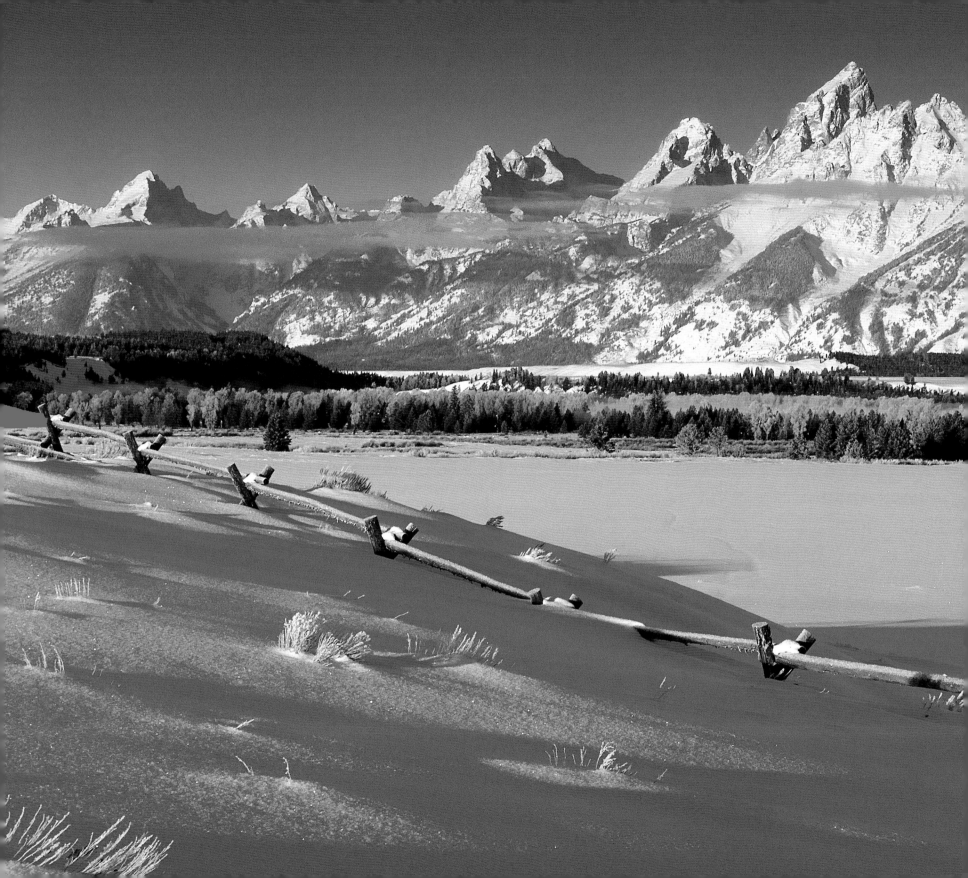

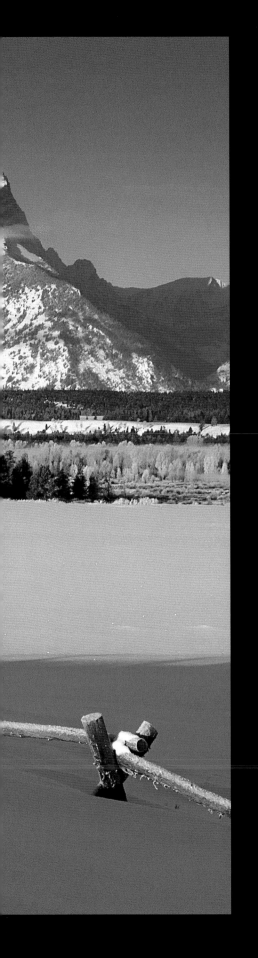

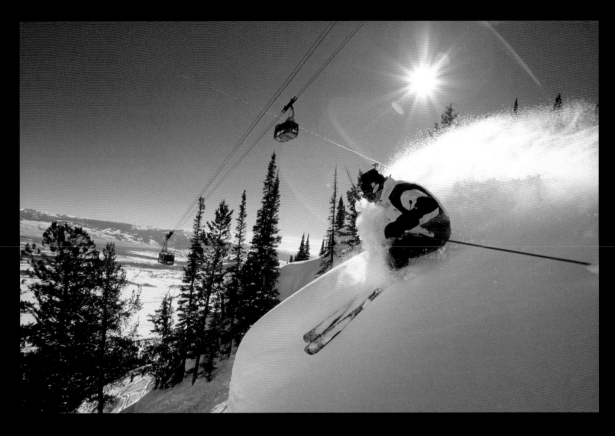

Above: Perfect powder at Jackson Hole Mountain Resort. PHOTO BY BOB WOODALL/FOCUSPRODUCTIONS.COM

Left: Fence-high drifts on the Triangle X Ranch.

Facing page: Sandhill cranes gather during their fall migration as a Teton Valley, Idaho, farmer plows his field late in the evening.

Below: The bliss of solitude: fishing on a misty autumn morning.

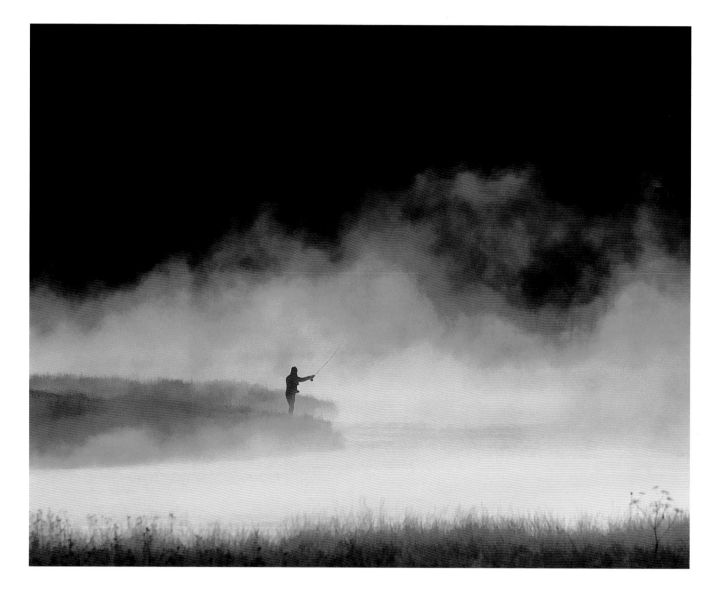

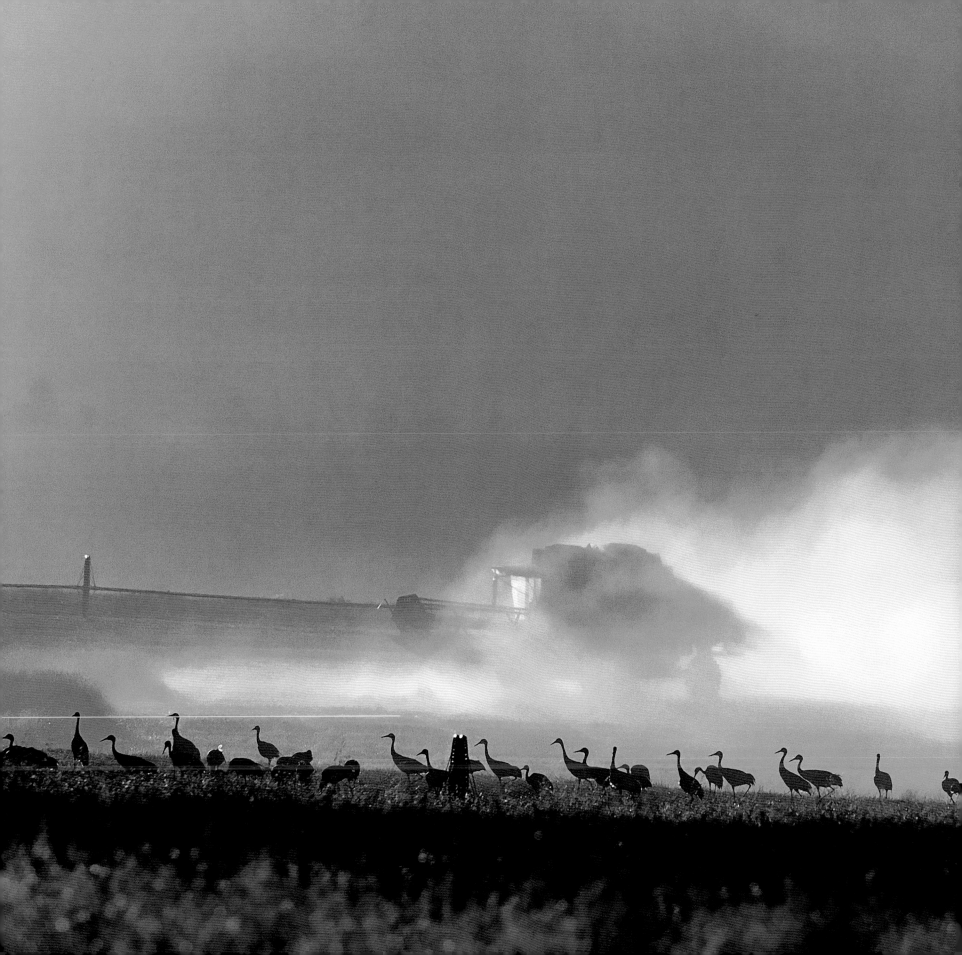

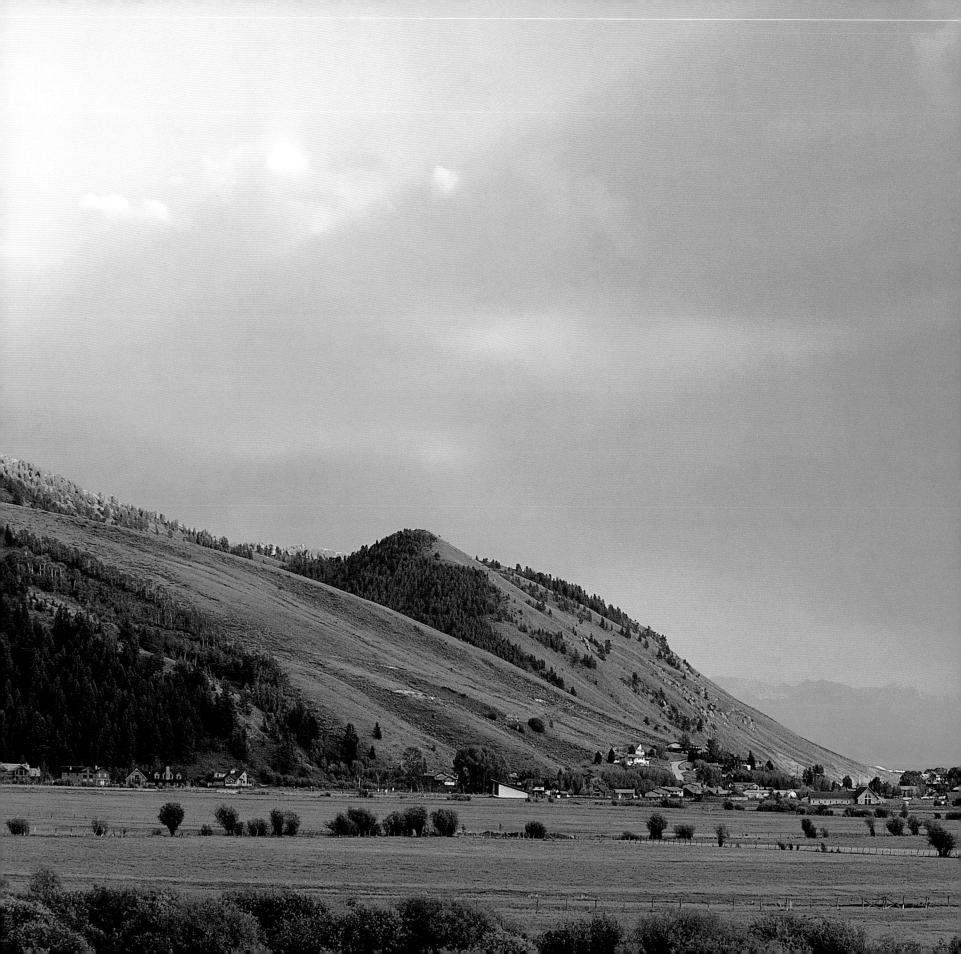

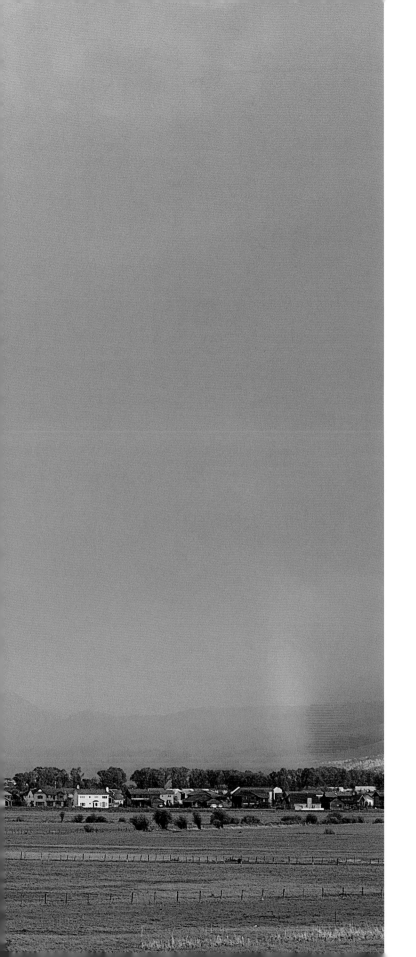

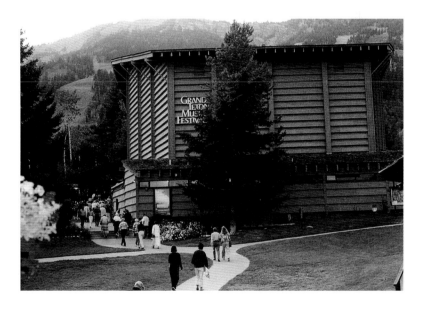

Above: Concert-goers stream into the Grand Teton Music Festival for one of the 40-plus chamber and symphonic performances offered in July and August.

Left: Afternoon rain showers and a rainbow enhance the sky between Jackson and Wilson. The Hoback Range rises on the far horizon behind High School Butte, which is in the foreground.

Above: A little Christmas cheer, Wyoming-style.

Right: Even the antler arches on the Jackson Town Square get decked for the holidays.

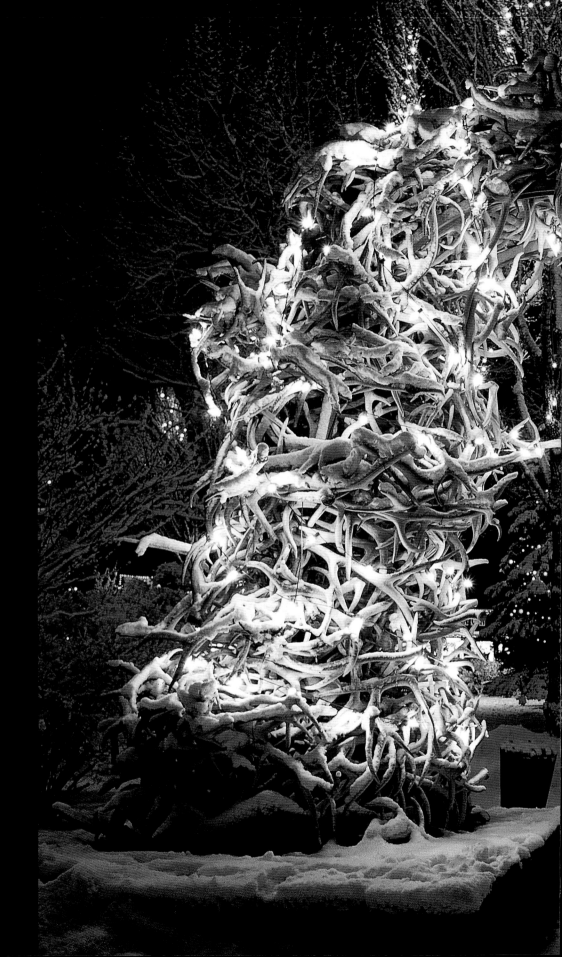

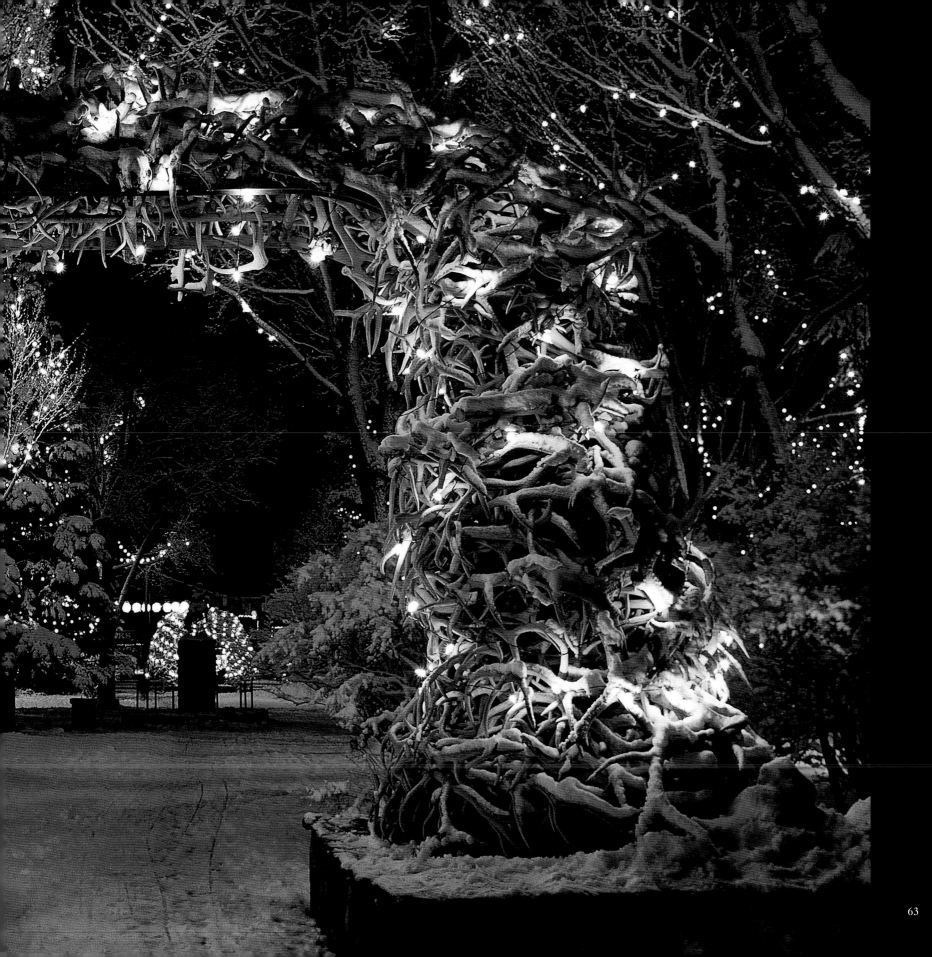

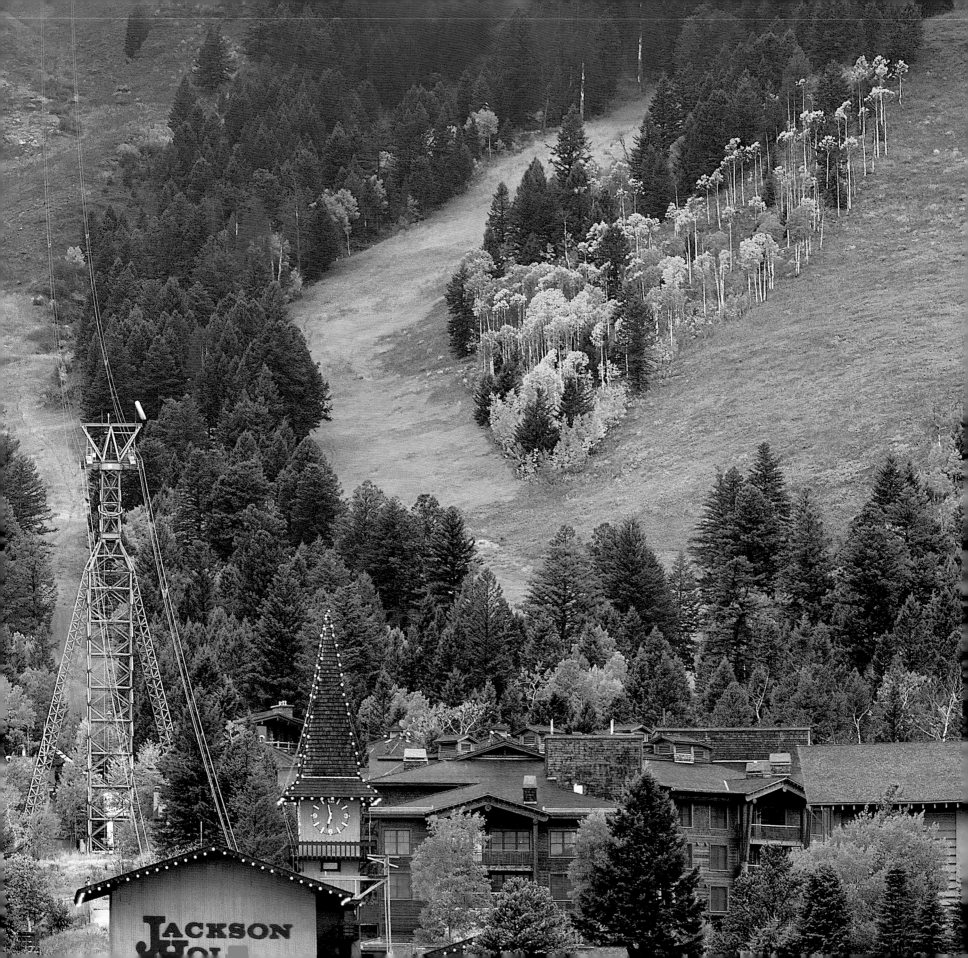

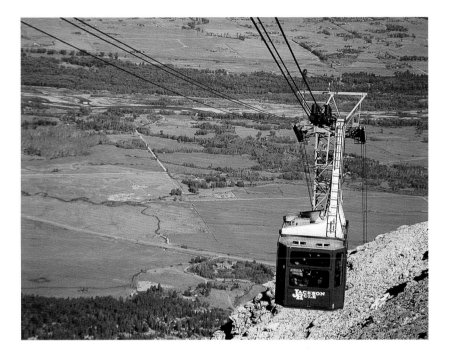

Above: Until September 2006, the 40-year-old aerial tram at Jackson Hole Mountain Resort carried passengers to the top of 10,450-foot Rendezvous Mountain for scenic viewing or winter skiing.

Left: Teton Village, at the foot of Jackson Hole Mountain Resort, with fall gold just beginning to torch the aspen.

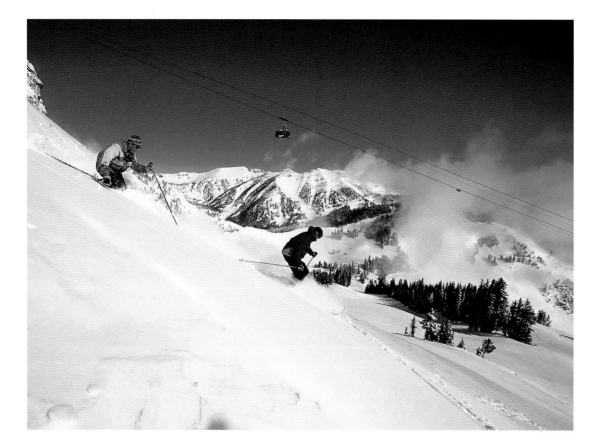

Above: Knee-deep in a winter wonderland. *Skiing* magazine ranked Jackson as America's best ski town. **PHOTO BY BOB WOODALL/FOCUSPRODUCTIONS.COM**

Right: Sleigh rides on the National Elk Refuge offer visitors a view of the Jackson Hole elk herd, below the profile of the Sleeping Indian.

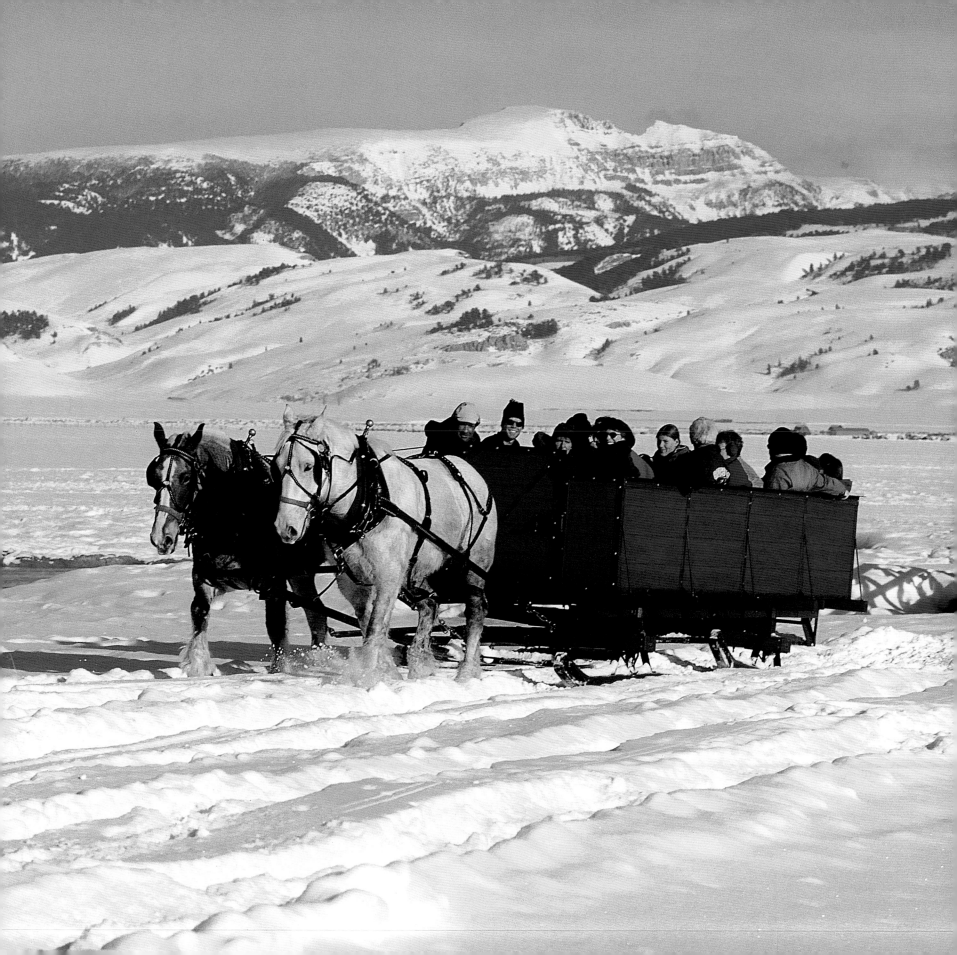

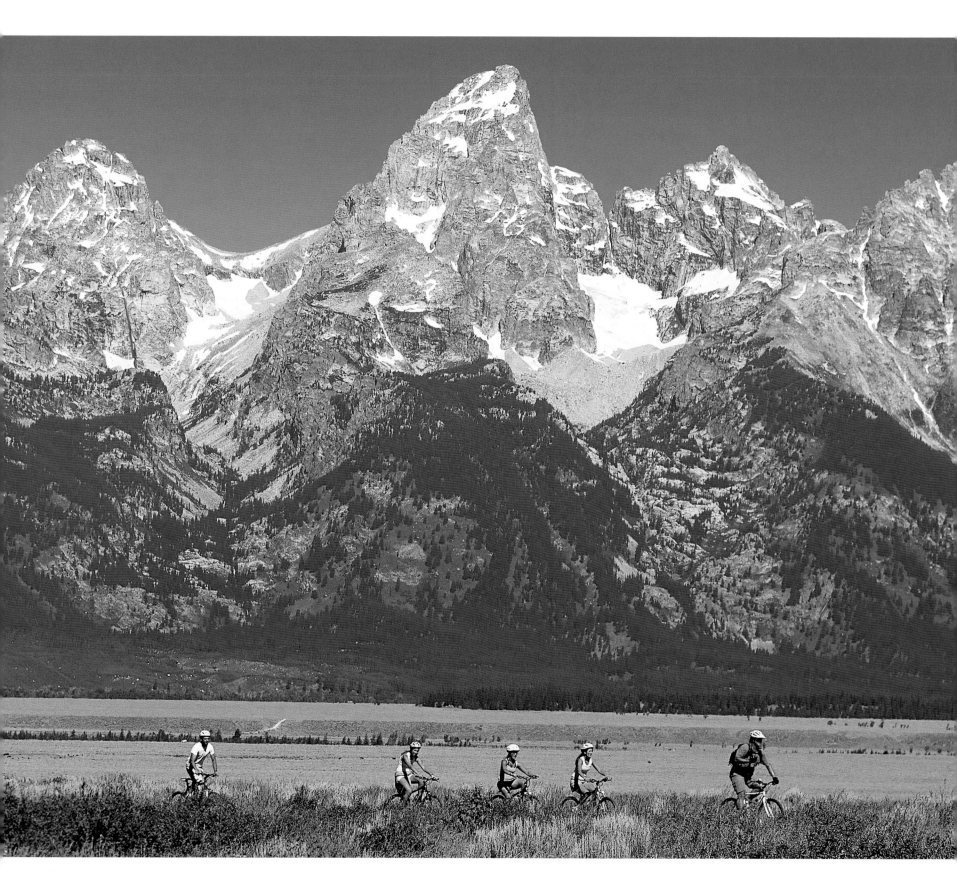

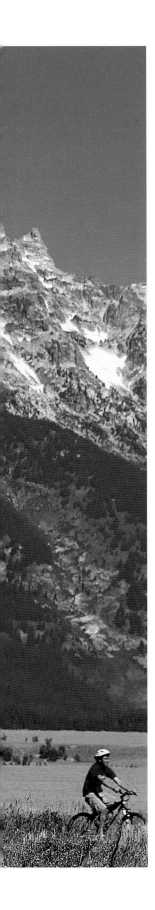

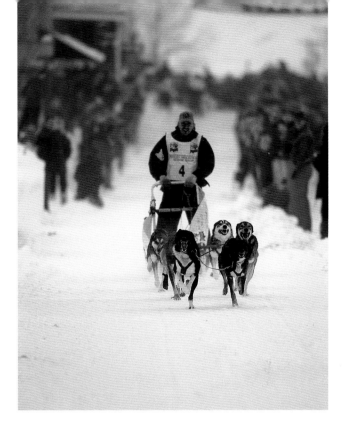

Right: Each January, up to 30 teams mush in the International Pedigree Stage Stop Dog Race, commonly known as the Jackson Hole Iditarod.

Left: Certain park roads in the Tetons offer outstanding rides for mountain bikers.

Below: Midwinter, quarter-mile-long cutter races are something like a Wild West version of chariot races.

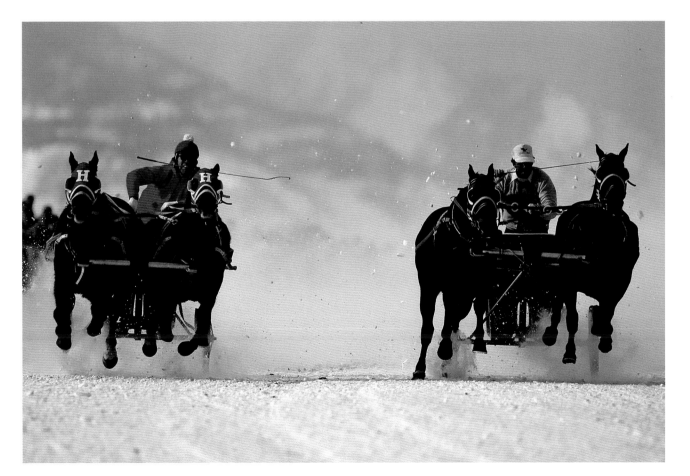

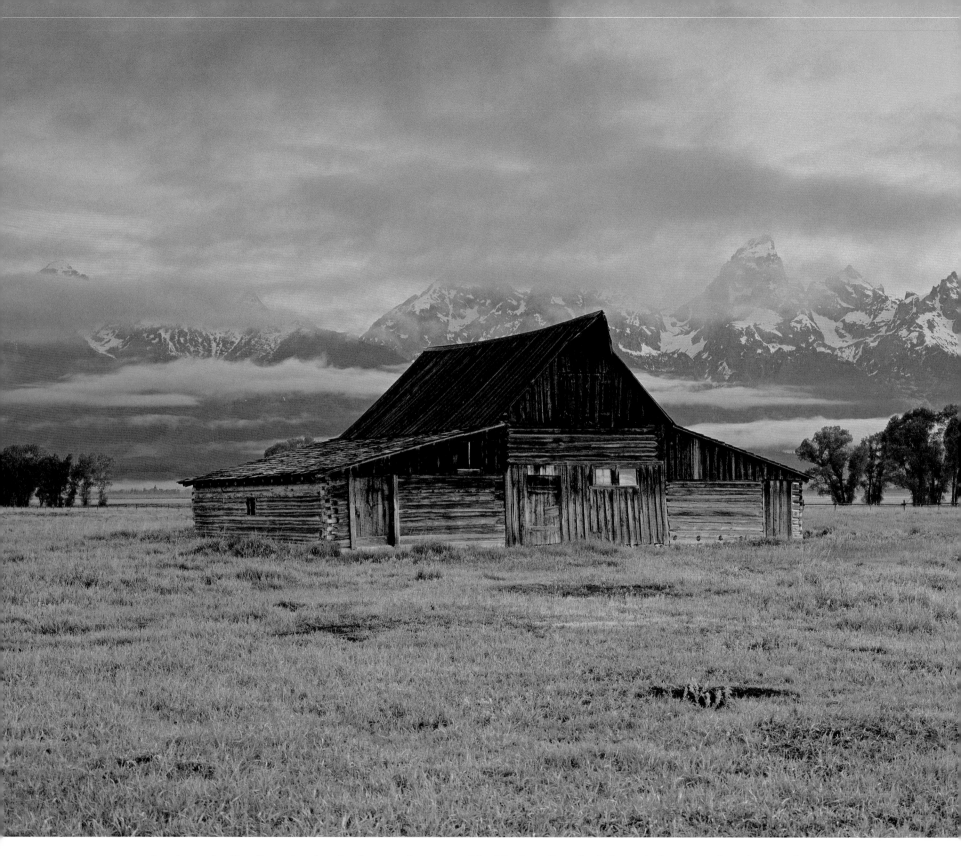

Sunrise and valley fog paint the air after a spring storm. The Moulton Barn, built by early homesteader John Moulton, is located in an area known as Mormon Row that was settled in 1896. The area is now a historic district.

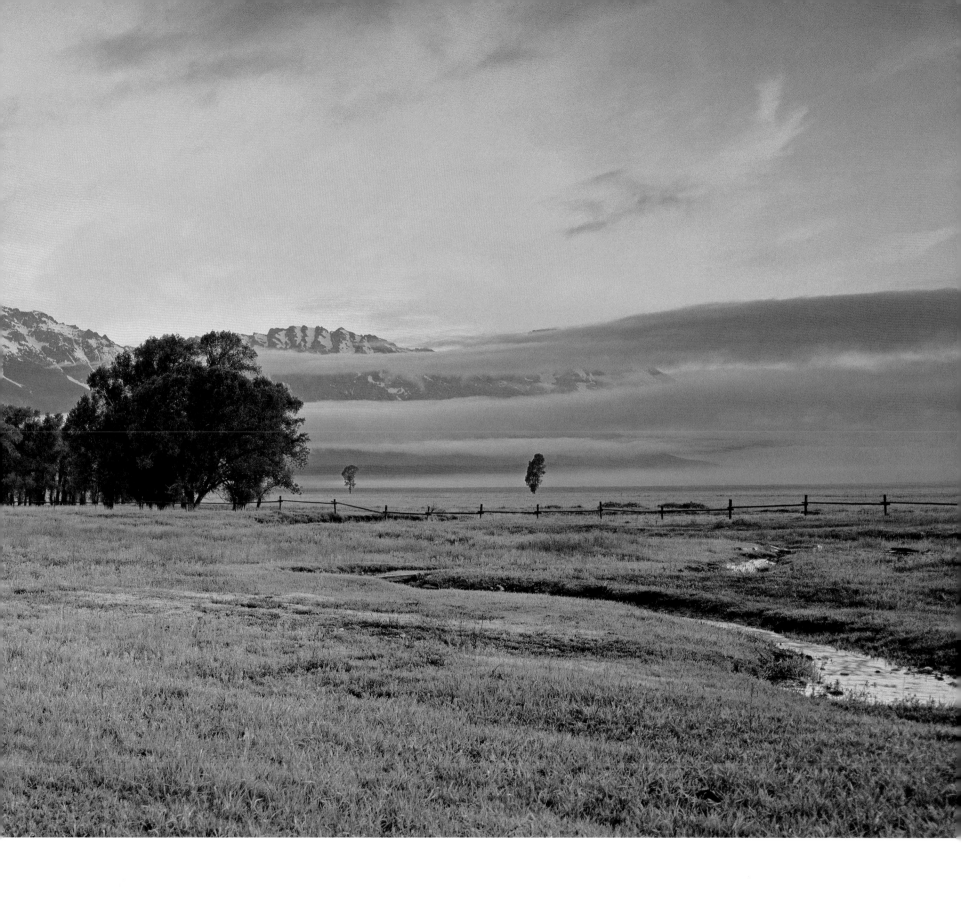

Right: The Chapel of the Transfiguration, built in 1925, is part of the park's historic district and is still used as a place to worship or hold weddings.

Below: A Canada goose and her downy flock take to the waters of Flat Creek.

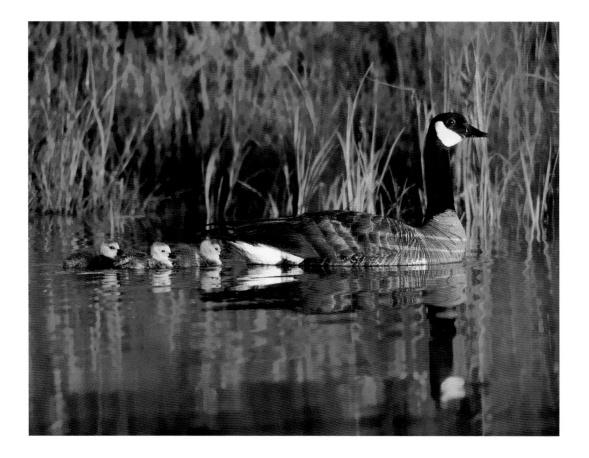

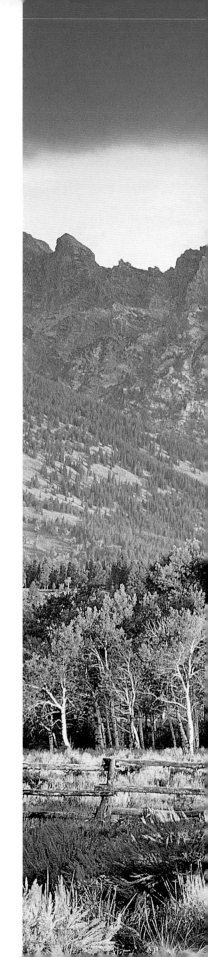

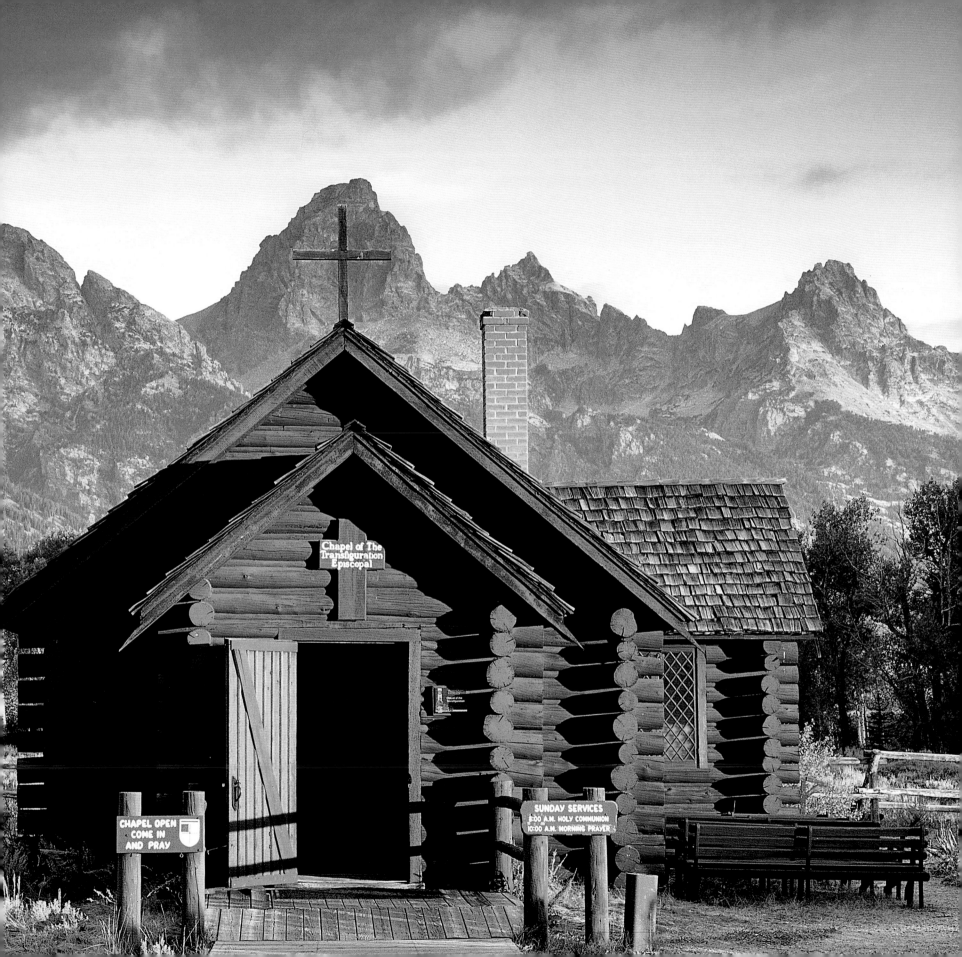

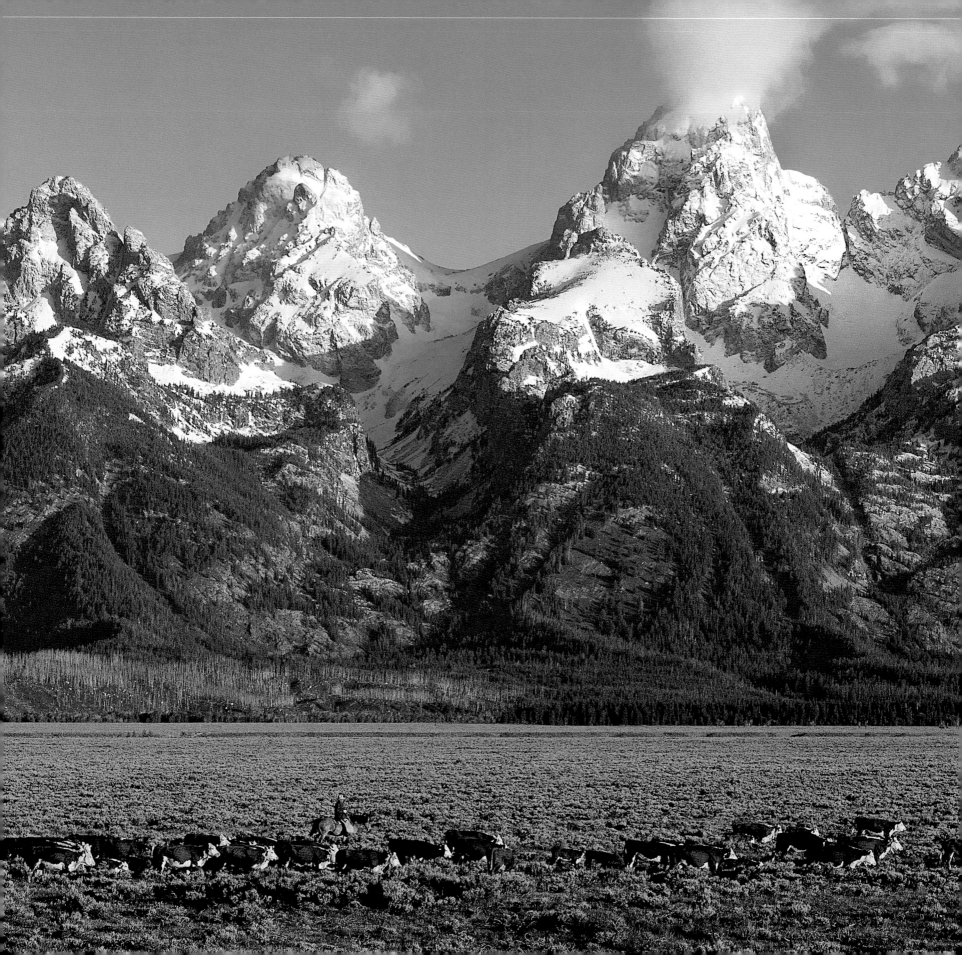

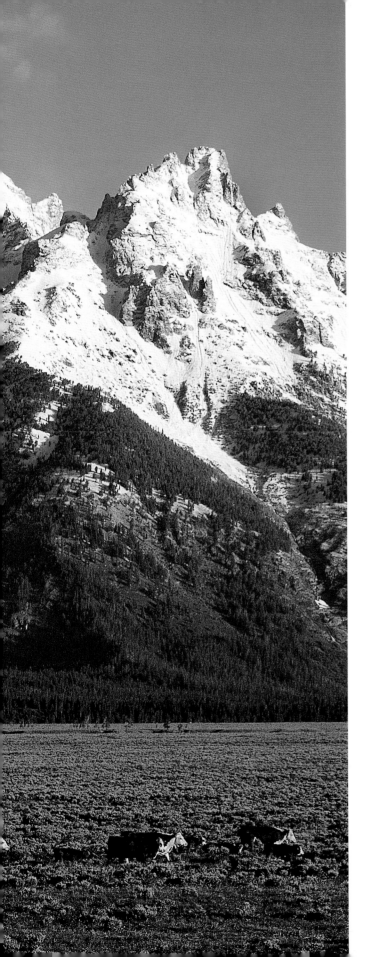

Left: Moving cattle through Antelope Flats to summer pasture. Ranching is an important part of Jackson Hole's heritage.

Below: Velvet on these antlers means the elk's rack is still growing. As soon as bull elk shed their velvet in mid-August, they begin shining up their antlers for the start of the rut in early September.

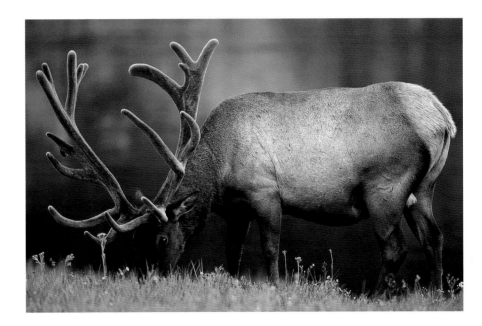

Right: Hidden Falls, one of the park's most visited destinations, is actually a cascade that spills 200 feet to the ground.

Far right: A scenic boat ride across Jenny Lake takes visitors to the base of Cascade Canyon and to trails leading to Hidden Falls, Inspiration Point, and Lake Solitude.

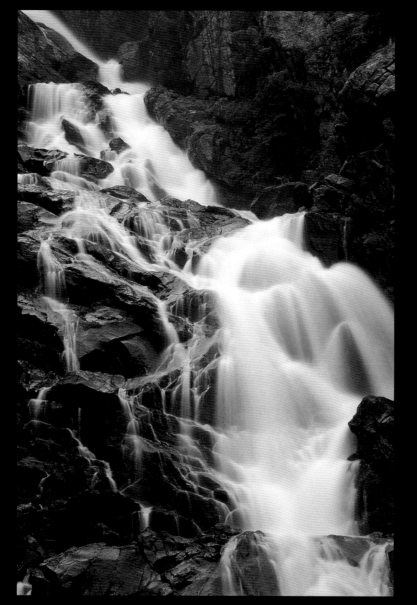

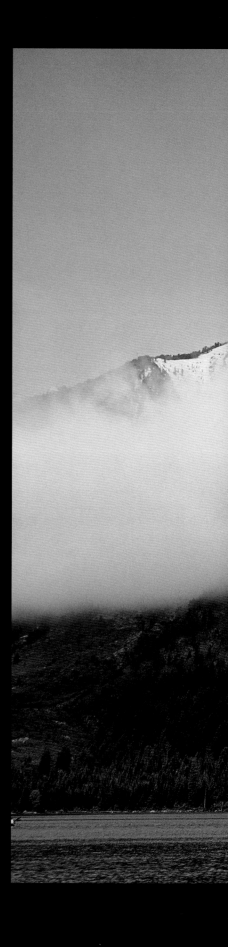

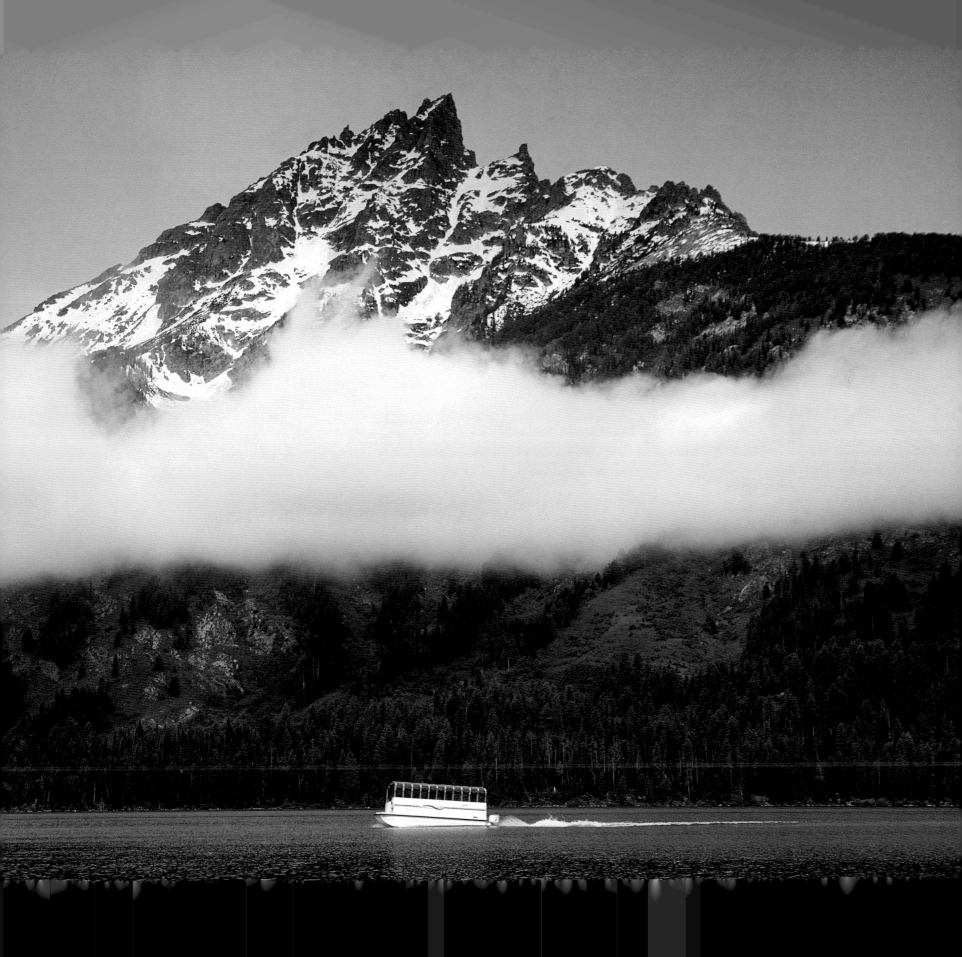

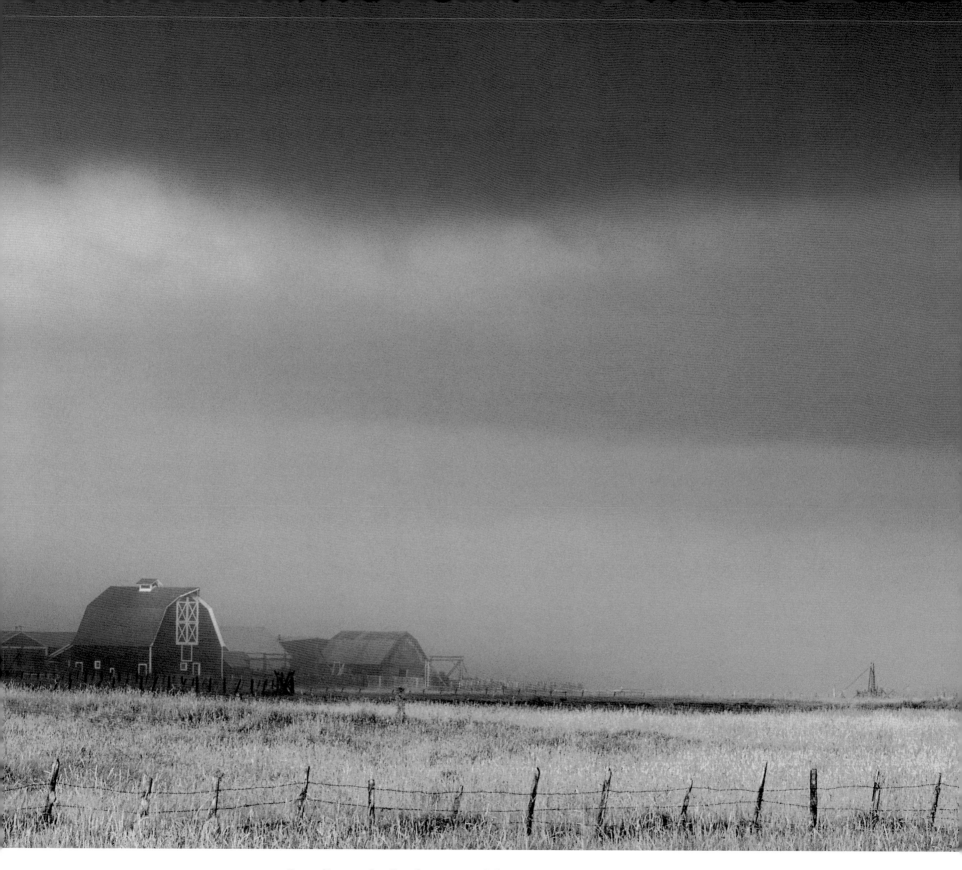

Fence lines and valley fog surround the Brown Ranch in Spring Gulch.

In early summer, wild blueflax (above) and harebells (right) border many of the valley's bike paths and hiking trails.

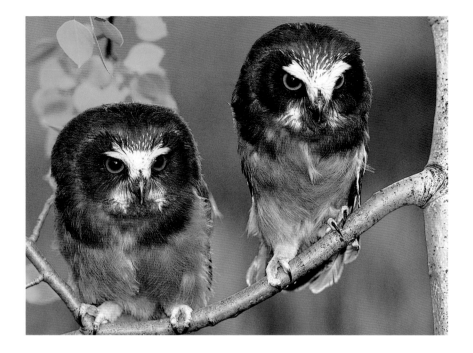

Above, top: Northern saw-whet owl chicks cling to the safety of an aspen branch.

Above, bottom: A pika suns itself on a lichen-covered boulder. These rock rabbits, as they are sometimes called, are at home among the talus slopes of Jackson Hole's high country.

Right: A hike over Paintbrush Divide, which links Paintbrush and Cascade canyons, makes you feel like you are walking on the top of the world.

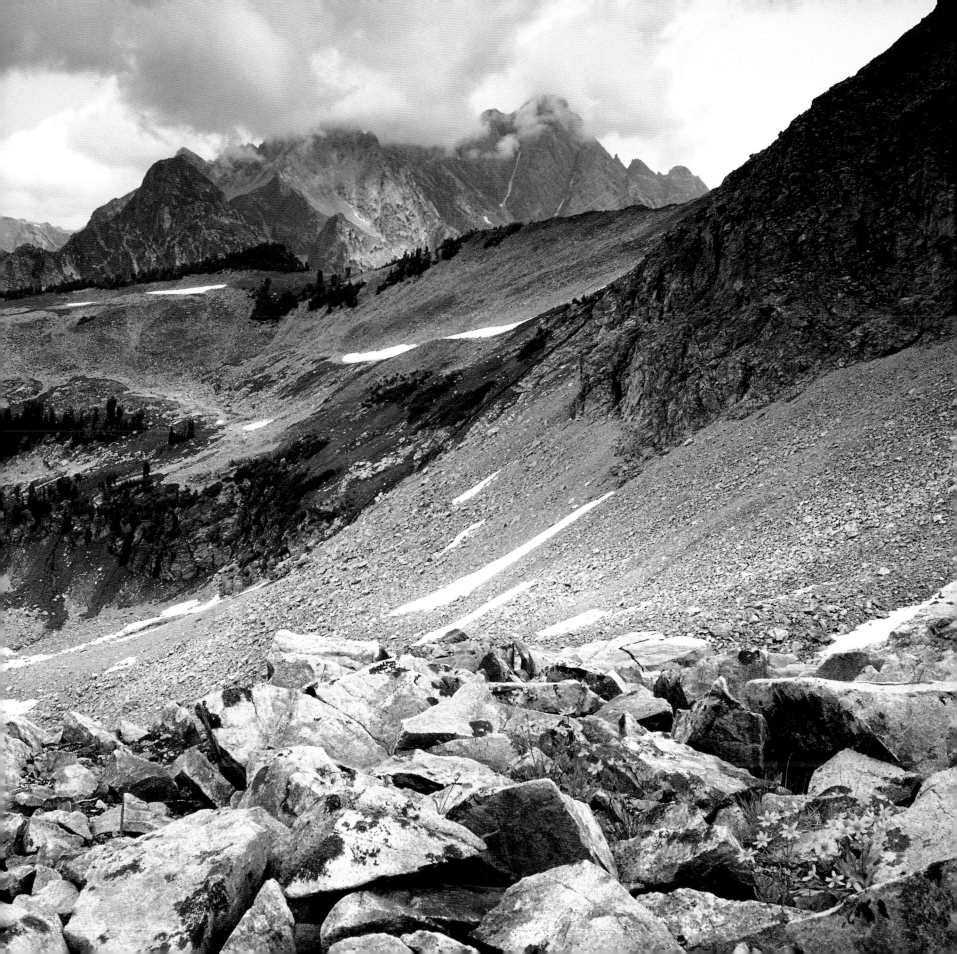

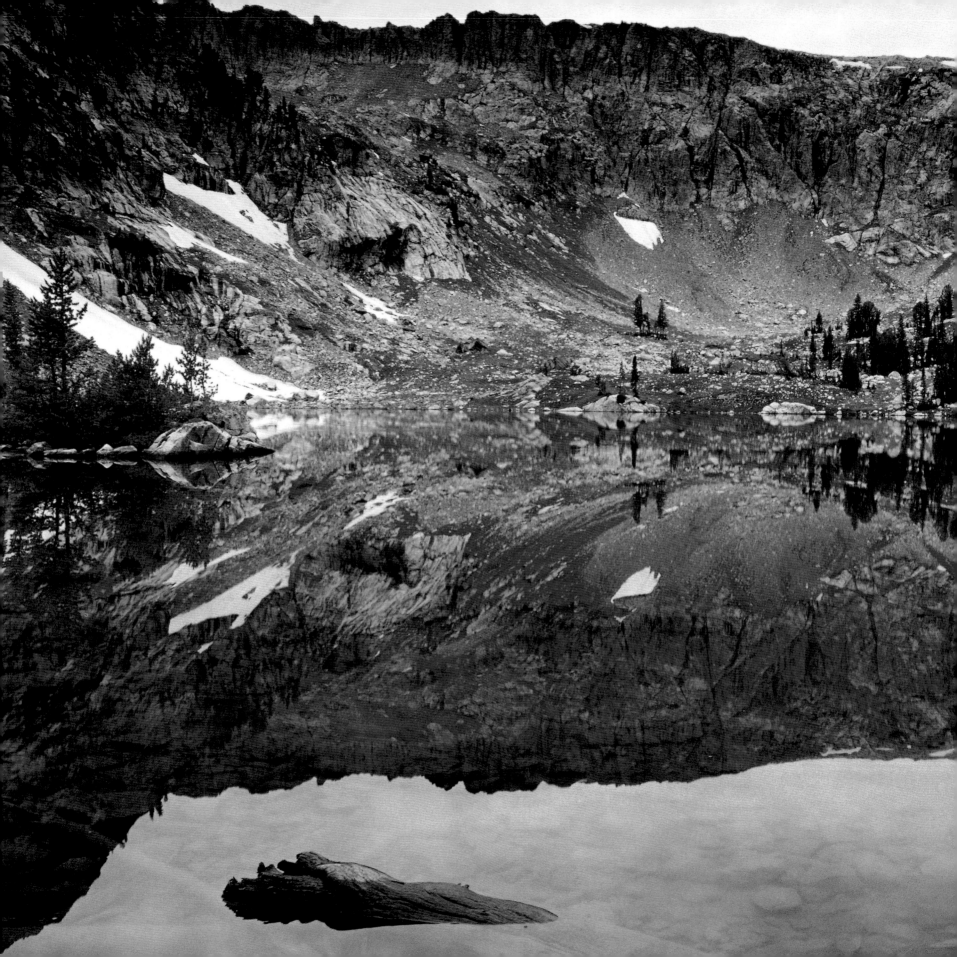

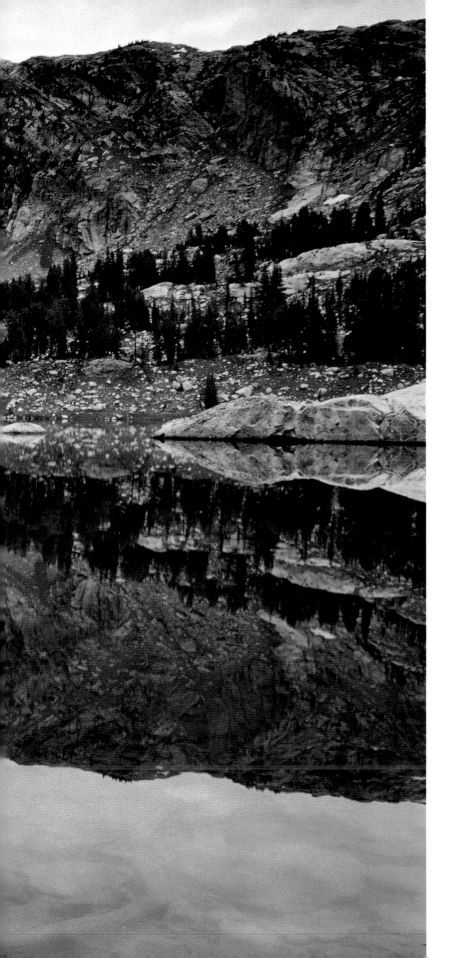

Above: Patches of lupine brighten the valley floor each June and can be found all summer long at higher elevations.

Left: The tranquility of Lake Solitude, with its mirrored surface, lies at the end of Cascade Canyon.

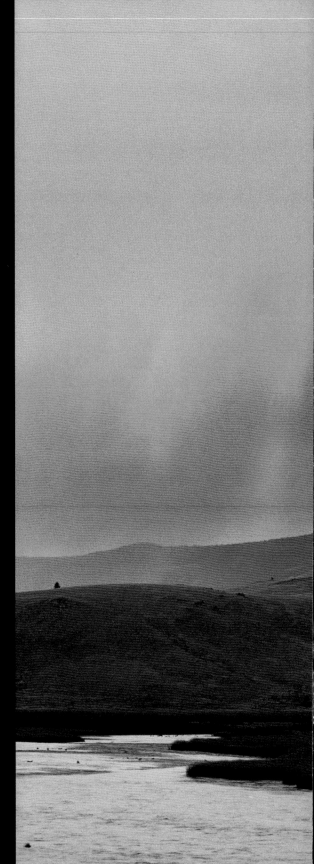

Right: An evening thunderstorm lights up the sky over Flat Creek and the Sleeping Indian.

Below: A cow elk struts through an autumn meadow in Grand Teton National Park. Fall begins with the bugling of elk in early September, and the rut continues on until late October.

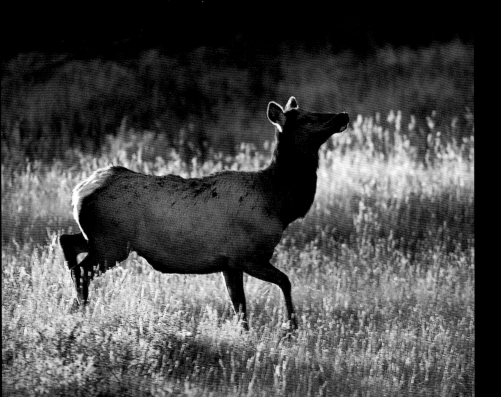

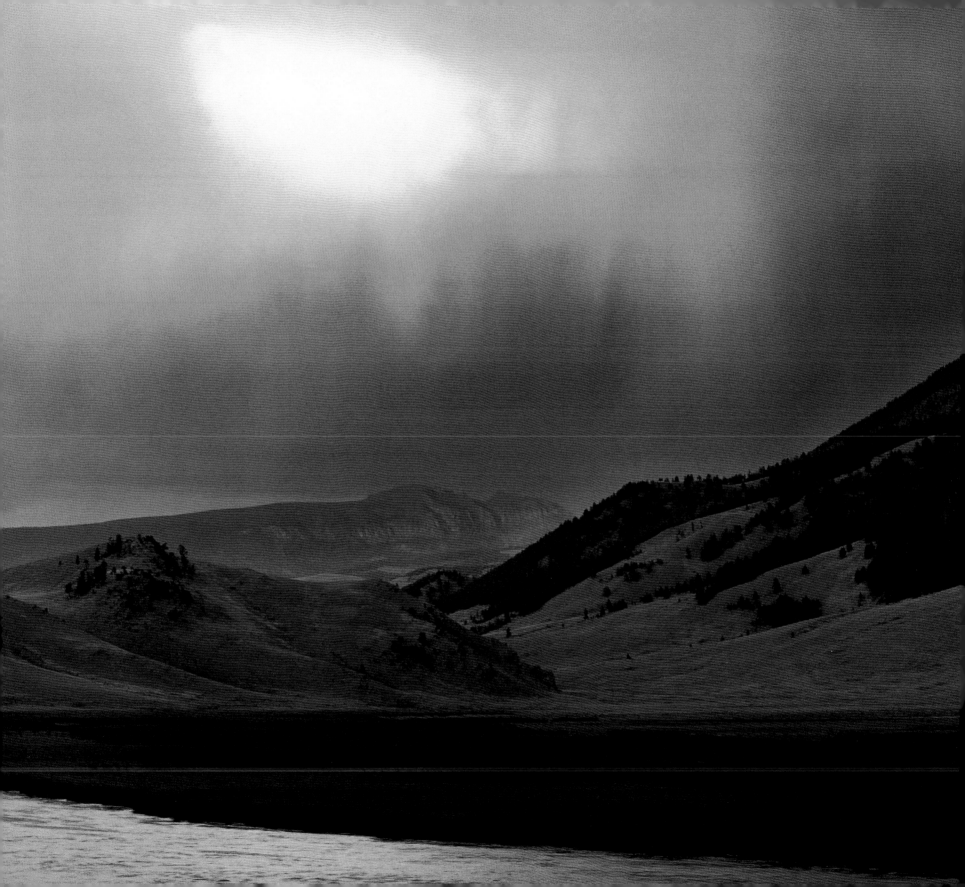

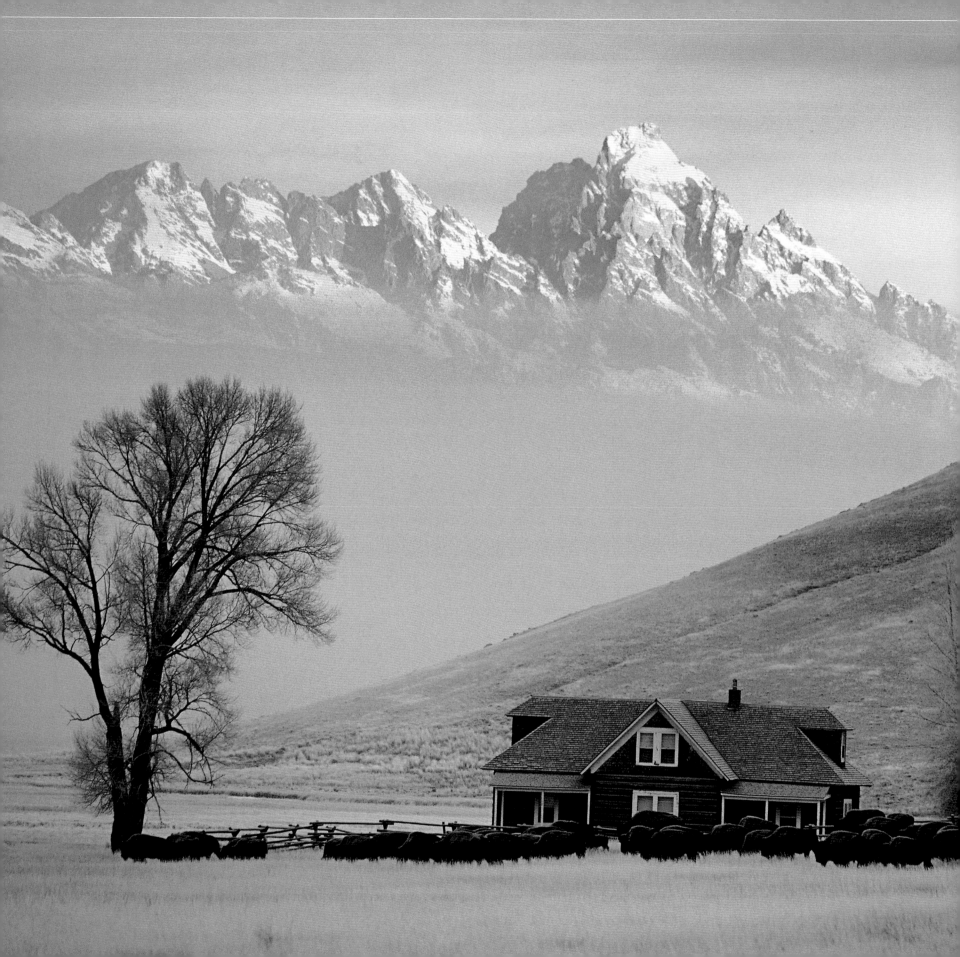

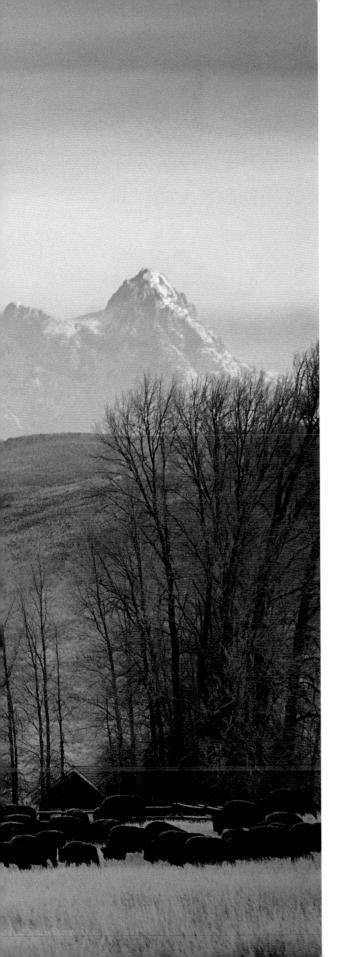

Left: A vision of days of gone by—bison migrating past the historic Miller Cabin on the National Elk Refuge. The cabin was built in 1900 by Robert E. Miller, the first supervisor of Teton National Forest, and purchased by the U.S. Fish and Wildlife Service in 1915 along with the 1,240 acres that formed the nucleus of the refuge. In 1969 it was placed on the National Register of Historic Places.

Below: Wolves, drifting south from Yellowstone National Park, discovered the elk refuge in the winter of 1998–1999 and have visited ever since. There are currently three packs that call Jackson Hole home.

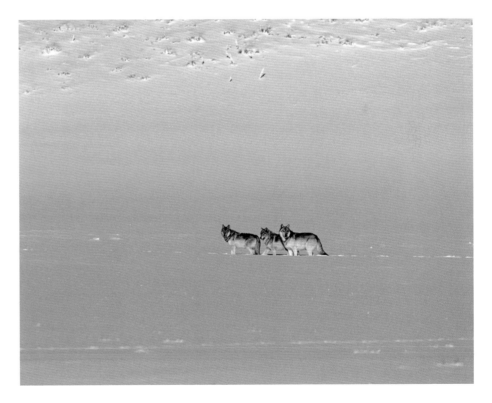

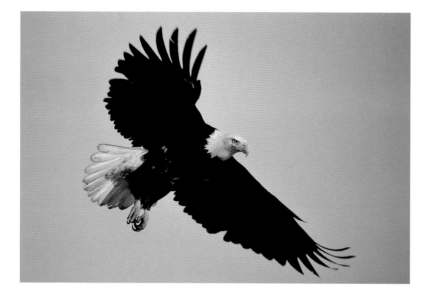

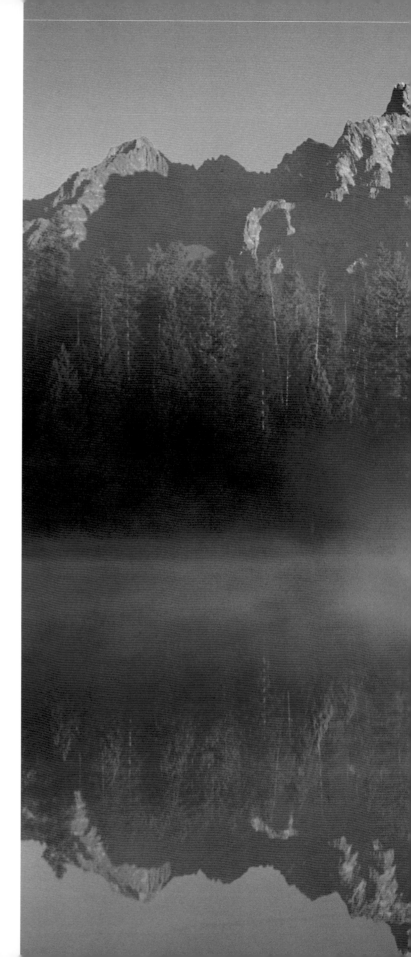

Above, top: The valley supports a healthy year-round population of bald eagles.

Above, bottom: A common merganser chick hitches a ride on its mother's back on String Lake.

Right: Mount Moran is reflected in the calm waters of String Lake. This shallow lake, set between Leigh and Jenny lakes, is the perfect place for picnicking, hiking, and canoeing and is one of the few lakes warm enough for a summer swim.

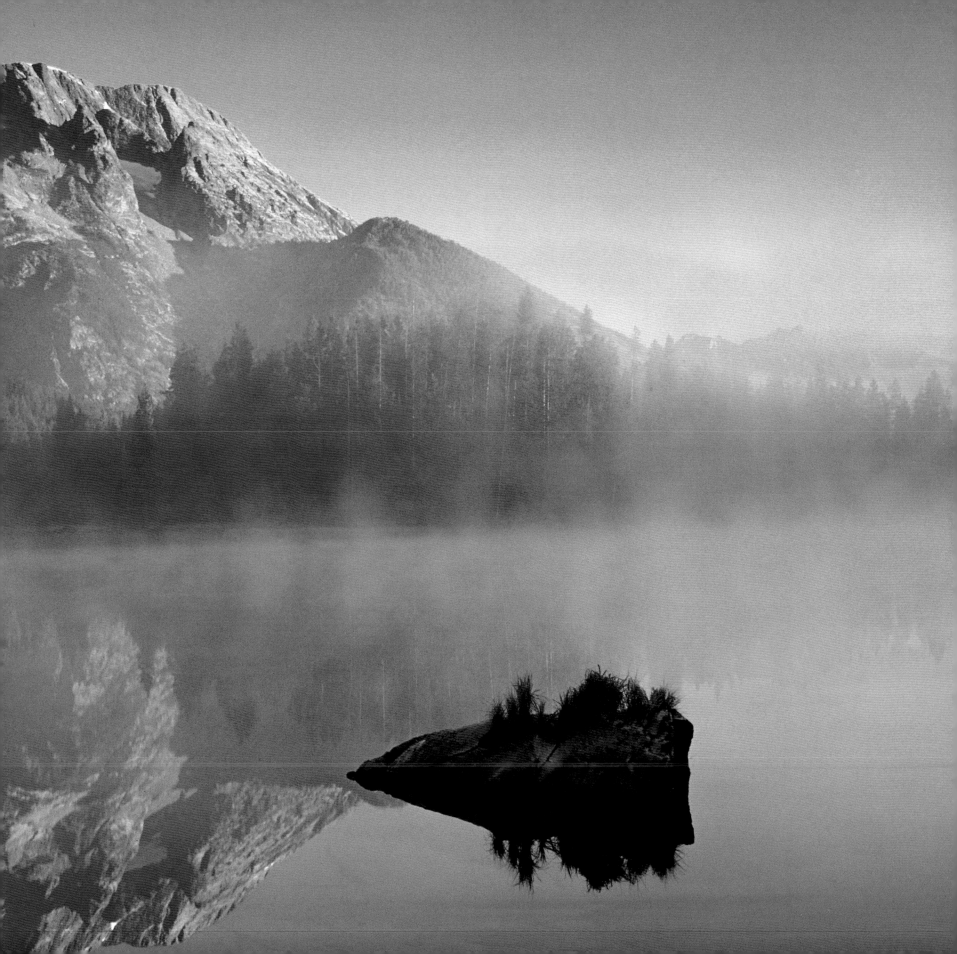

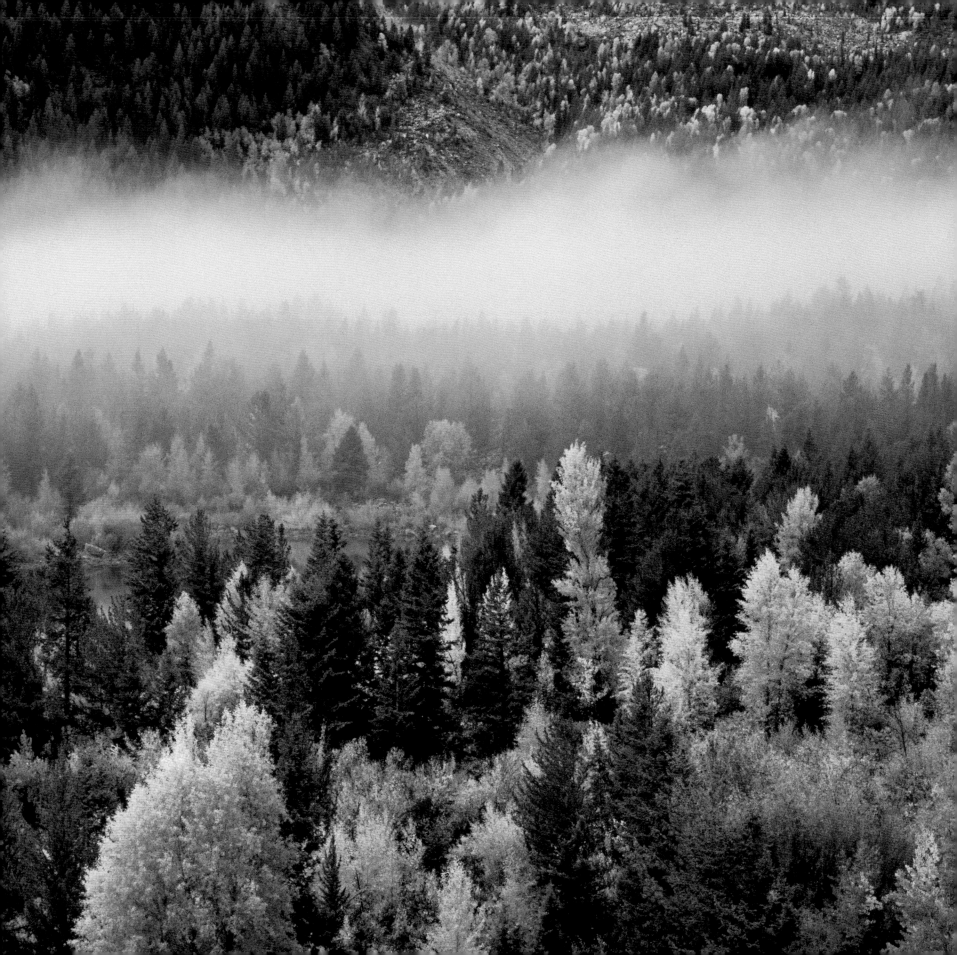

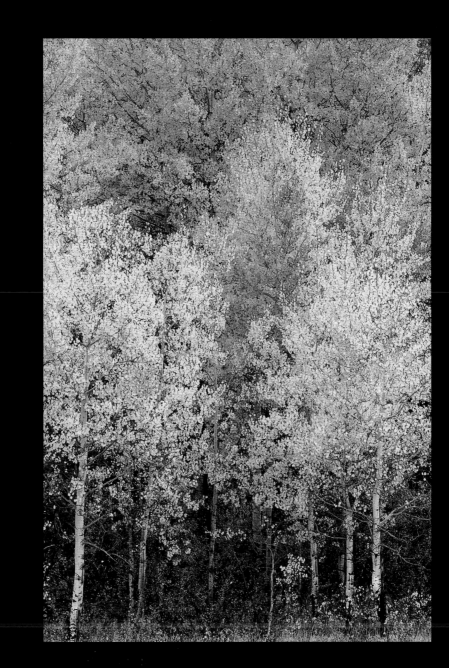

Left: Quaking aspens put the finishing touches on their annual change from green to gold. The peak of fall color hits Jackson Hole around the last week of September.

Far left: Cottonwoods and aspen trees add a little fall color to the Gros Ventre Slide, east of Kelly. In 1925, fifty million cubic yards of rock slid down the north side of Sheep Mountain, damming the Gros Ventre River. It is the second largest landslide recorded in North America, after the Mount St. Helen's eruption and landslide.

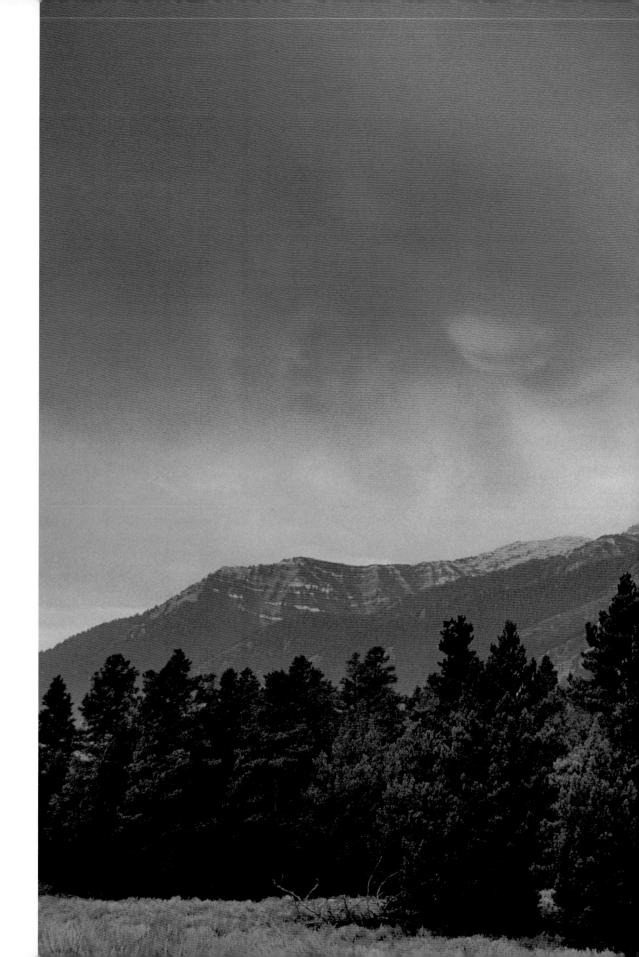

The Granite Canyon Trail, just inside the park boundary near Teton Village, offers this sweeping view of the southern end of the Teton Range and the lifts and bare ski runs of Jackson Hole Mountain Resort.

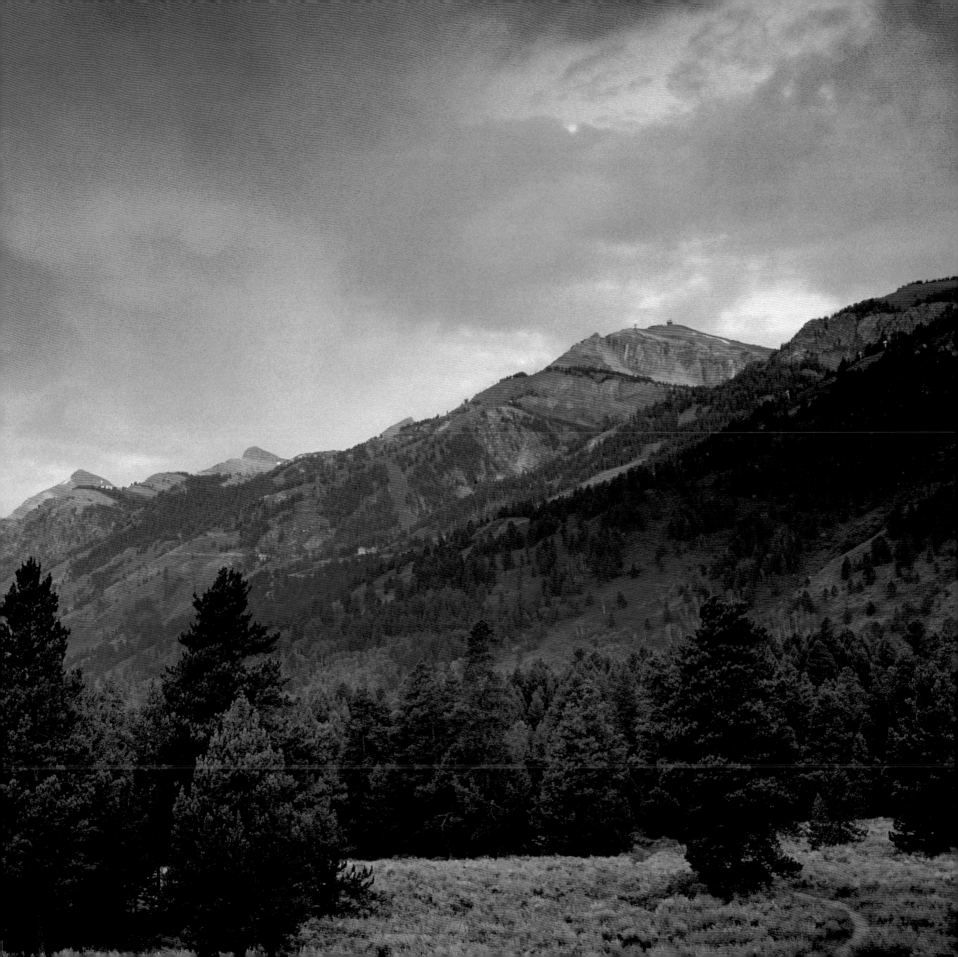

Right: Against a back-drop of aspen near Oxbow Bend on the Snake River, a bull moose pauses in his search for a mate.

Far right: Mountain maples add a splash of red beneath this aspen stand.

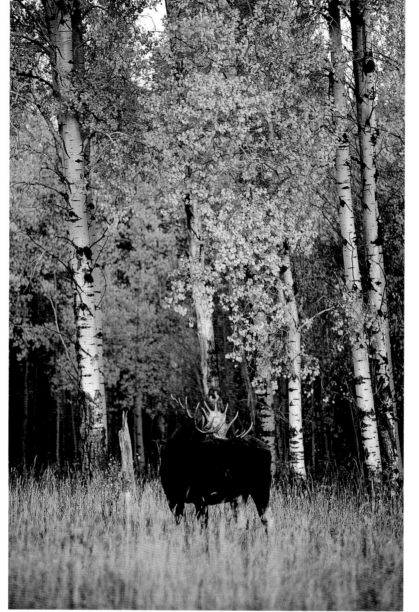

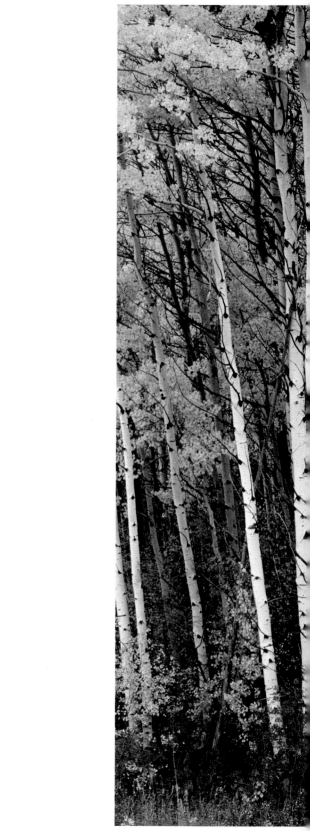

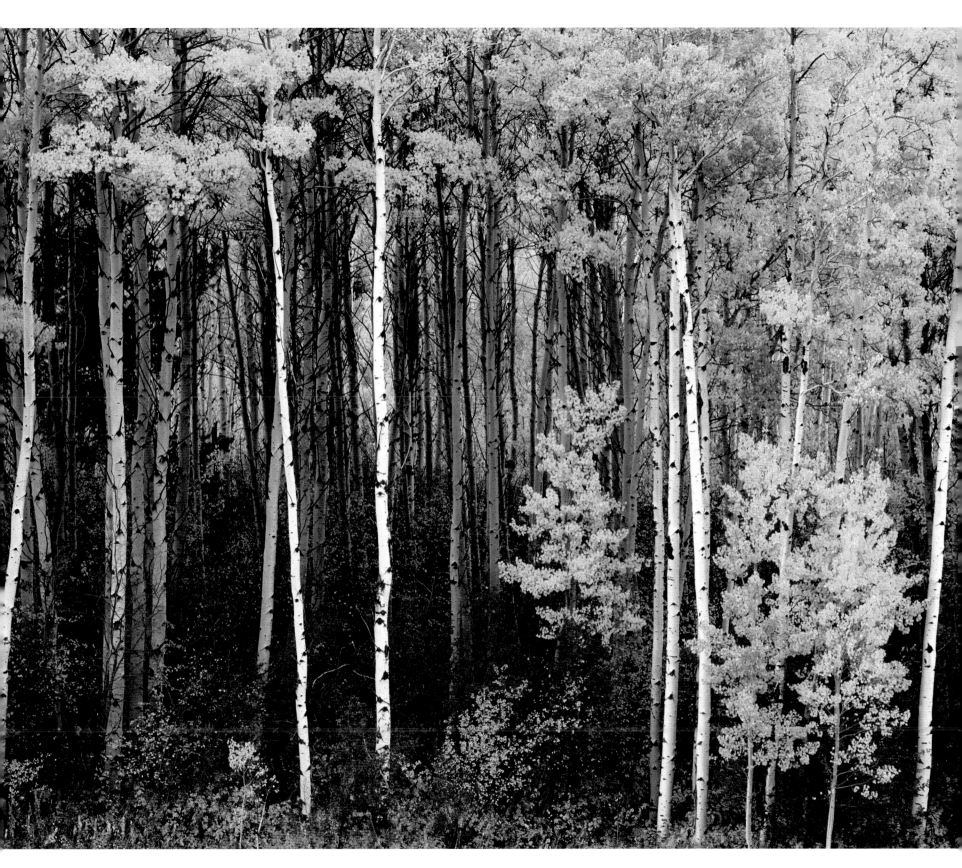

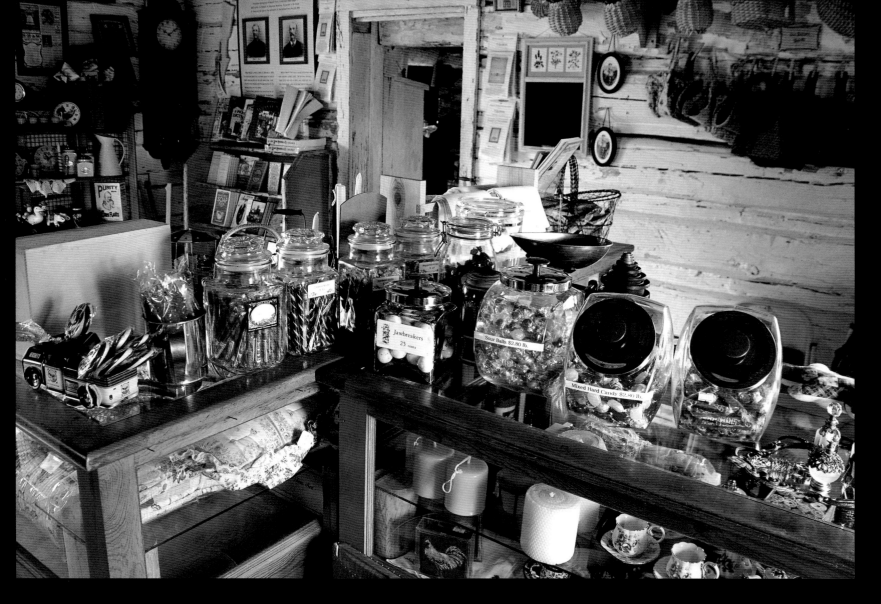

Peek inside Menor's Ferry store to see the lollipops and stick candy similar to those sold at the turn of the last century. It's a great place for children or adults to glimpse what it was like to live in early-day Jackson Hole.

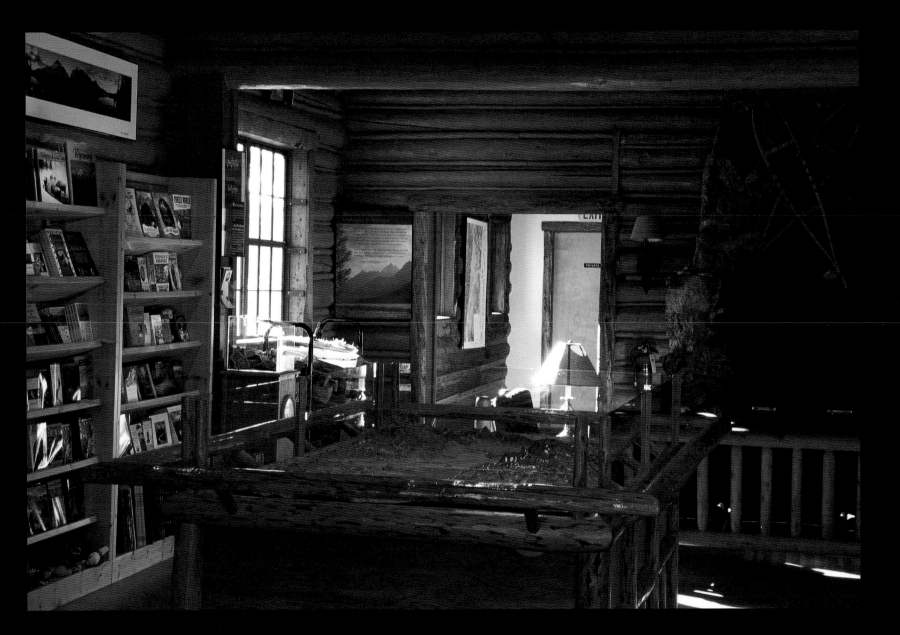

The Jenny Lake Ranger Station is an important place to start any backcountry excursion into Grand Teton National Park.

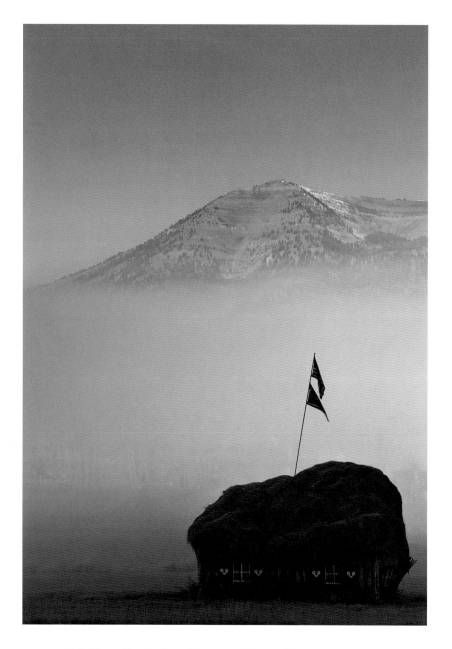

Above: Old Glory flies below Glory Bowl on a foggy morning. This haystack, south of town, is complete with shutters and a front door. It was the work of guerilla artists who, one night in the early 1990s, put it up with a sign that stated, "affordable housing in Jackson Hole." Locals took a liking to the artwork and it has remained a fixture ever since—as have rising real estate prices.

Right: A band of fog along the Snake River rises above horses grazing on the Triangle X Ranch, a working dude ranch created by John S. Turner in 1926. Vestiges of the Old West and the open range days still abound in Jackson Hole.

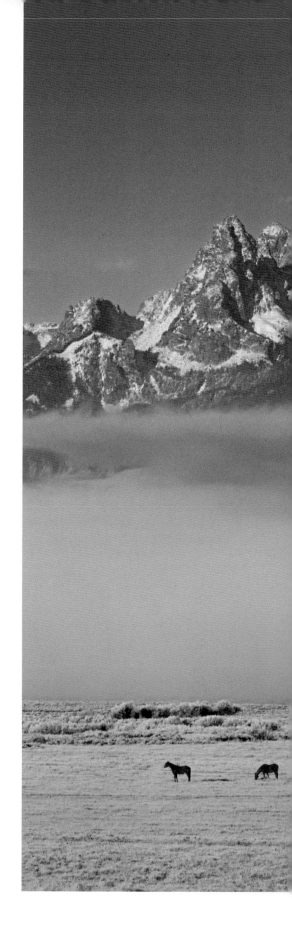

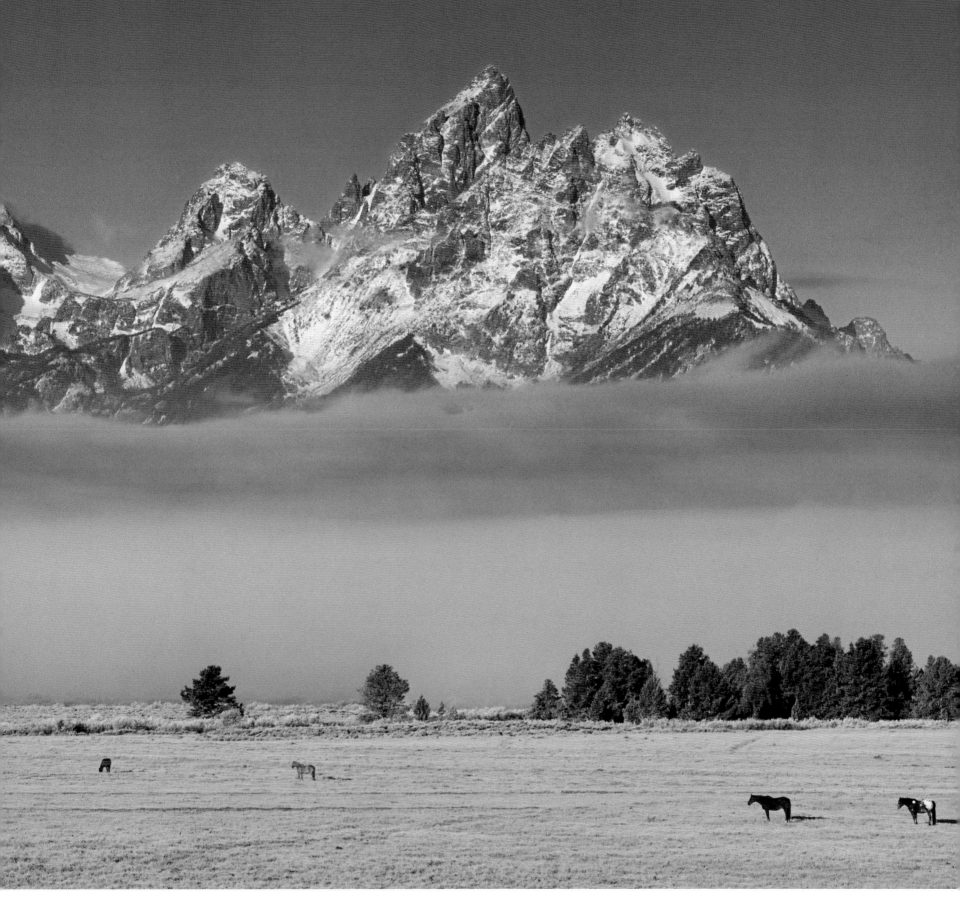

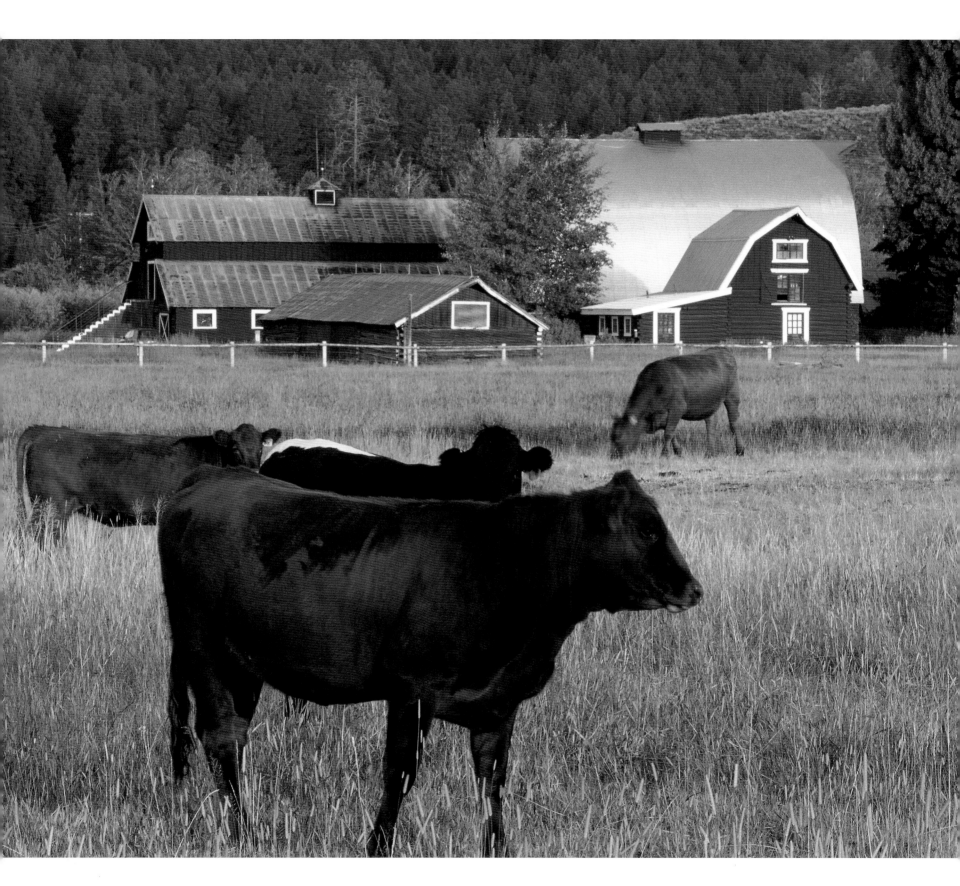

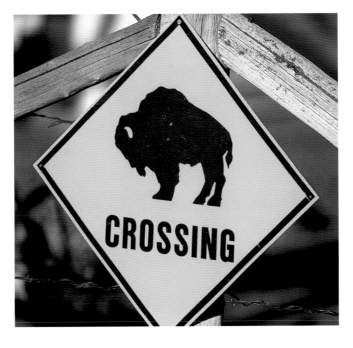

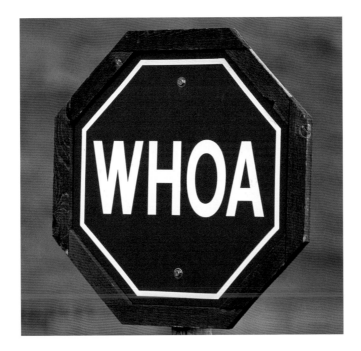

Left, top: How many places can put out a sign like this one? A bison crossing on Mormon Row.

Left, bottom: A stop sign, Jackson Hole–style, at Spring Creek Ranch.

Far left: Cattle mill about the bright red Hardeman Barn near downtown Wilson. From his humble beginnings in the Jackson area in 1915, Gerritt Hardeman became a very successful rancher.

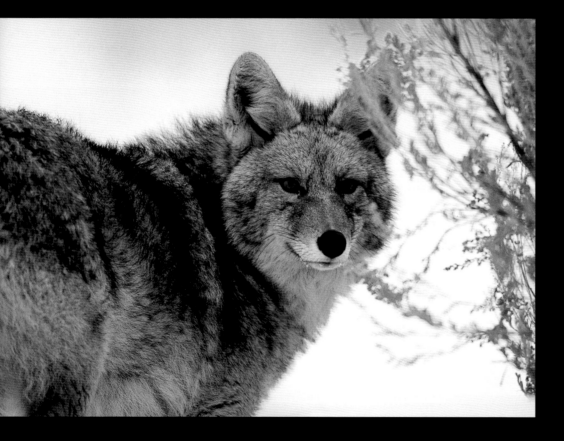

Above: Coyotes can be seen or heard throughout the valley. There is nothing like the "song dog" serenade to make you feel that you are truly in the West.

Right: Frosted cottonwoods line Fall Creek Road on a below-zero morning.

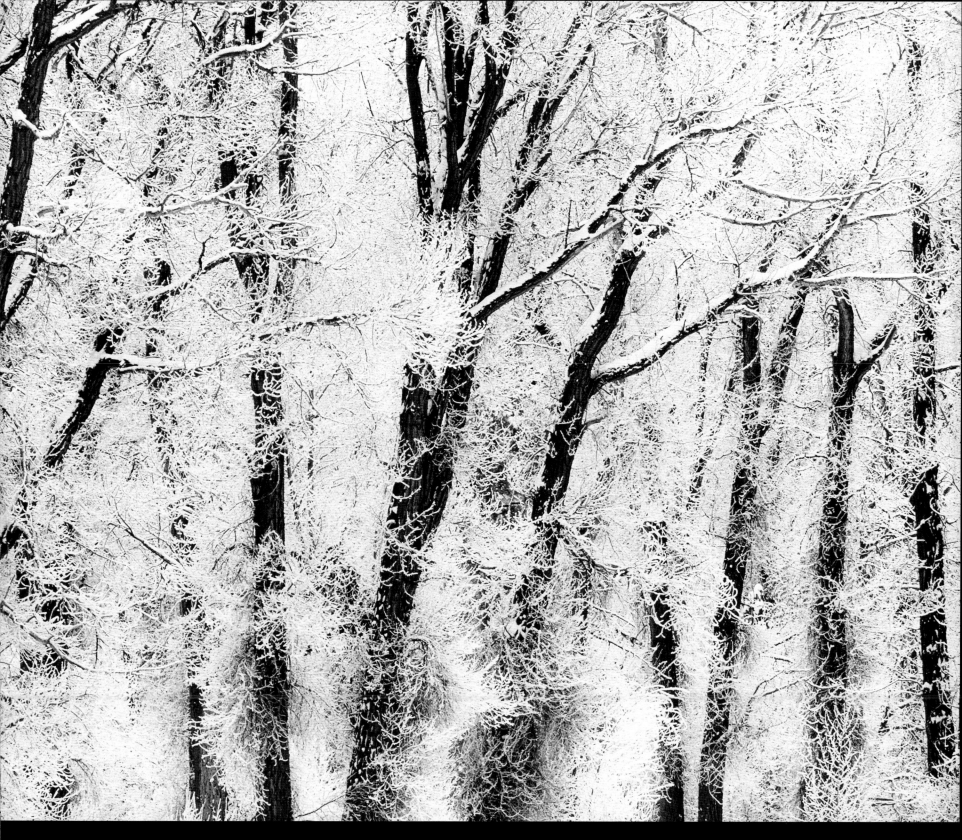

Right: The western meadowlark brings its lilting song of spring to the hayfields near Kelly.

Far right: In its heyday during the 1920s, the Bar BC Ranch was known as one of the best dude ranches in the West. Located on the west bank of the Snake River, a few miles upstream from Moose, this ranch operated from 1911 until 1986, when it became part of the park. Guest ranches or "dude" ranches were one of the first economically viable ventures in Jackson Hole.

Below: A red fox kit walks the line on a backrail fence in Wilson.

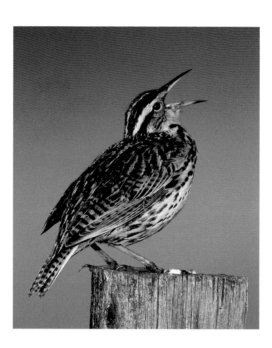

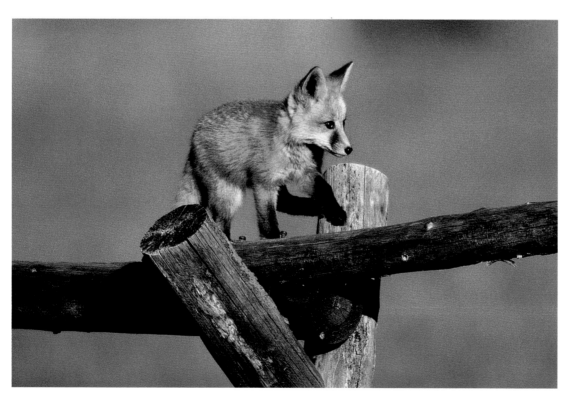

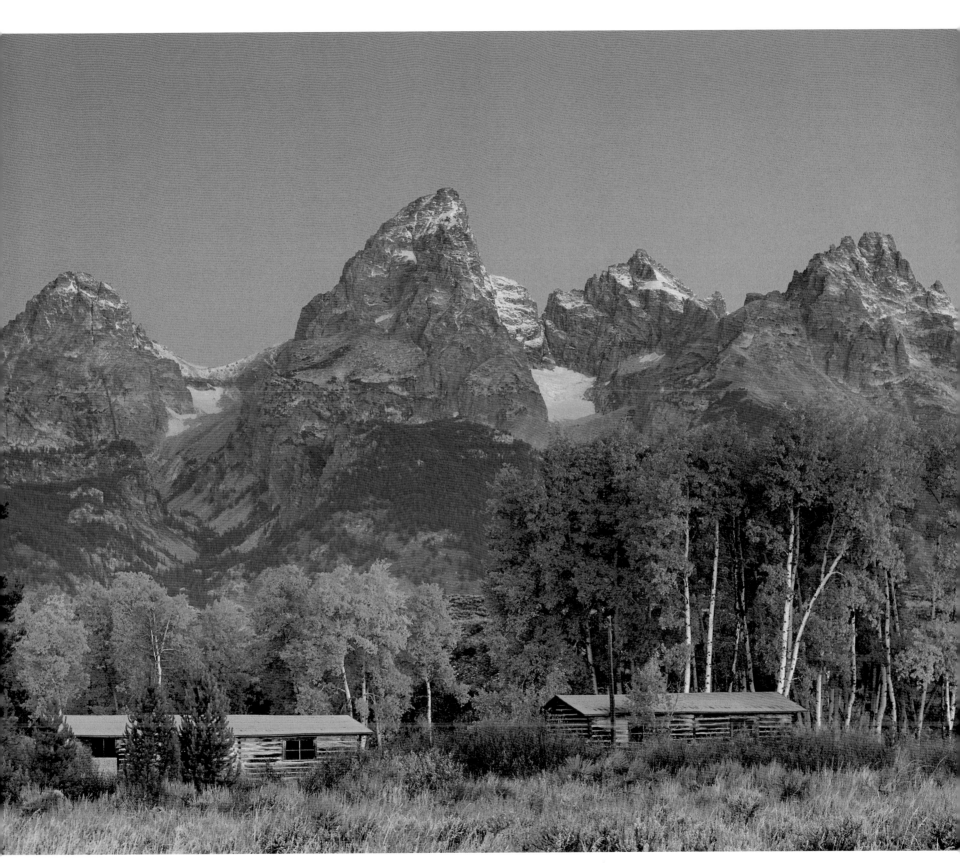

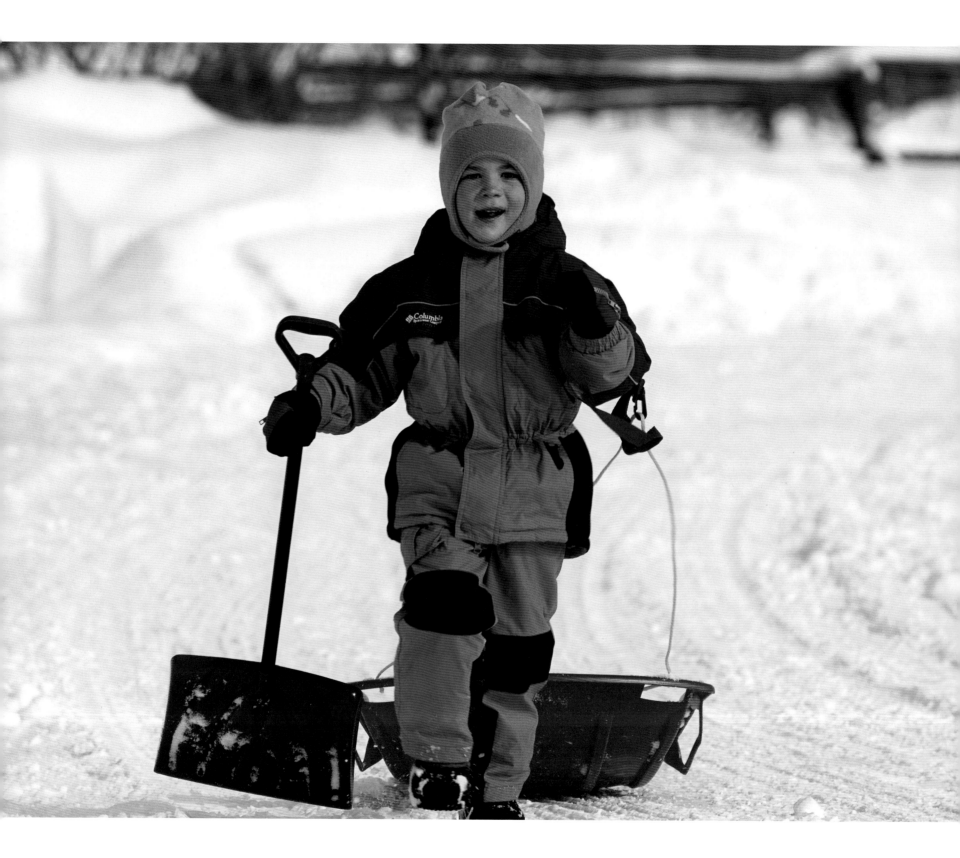

Facing page: A sled and a shovel are two good ingredients for a little winter fun.

Below: A cow moose eyes the Shane Cabin, just east of Kelly Warm Springs. Built for the set of the enduring western classic film, *Shane,* in 1953, it is one of the few physical reminders of Jackson Hole's legendary movie-making past.

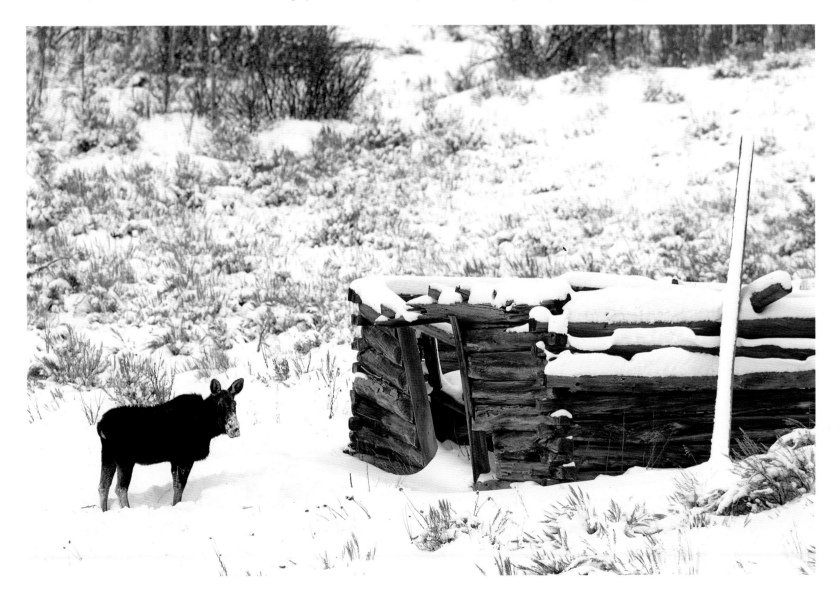

Right: A very faint crescent moon appears in the sky at dusk above Mount Moran and a tranquil Jackson Lake.

Below: Elk migrating across the Walton Ranch, between Jackson and Wilson, are treated to a Halloween sunset.

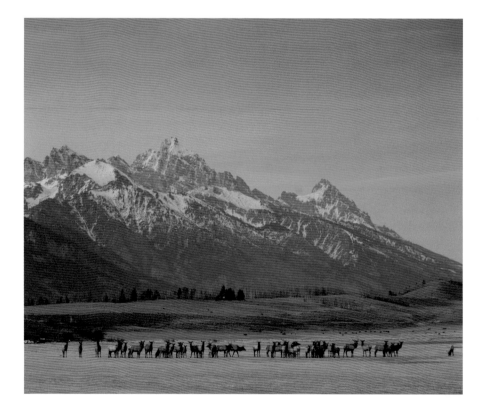

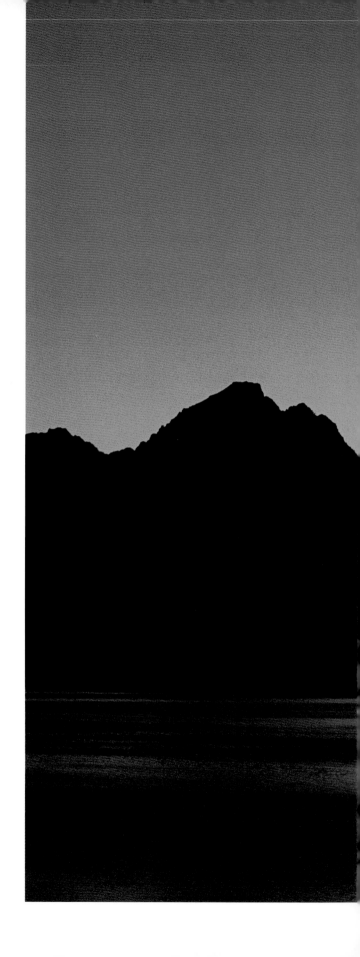

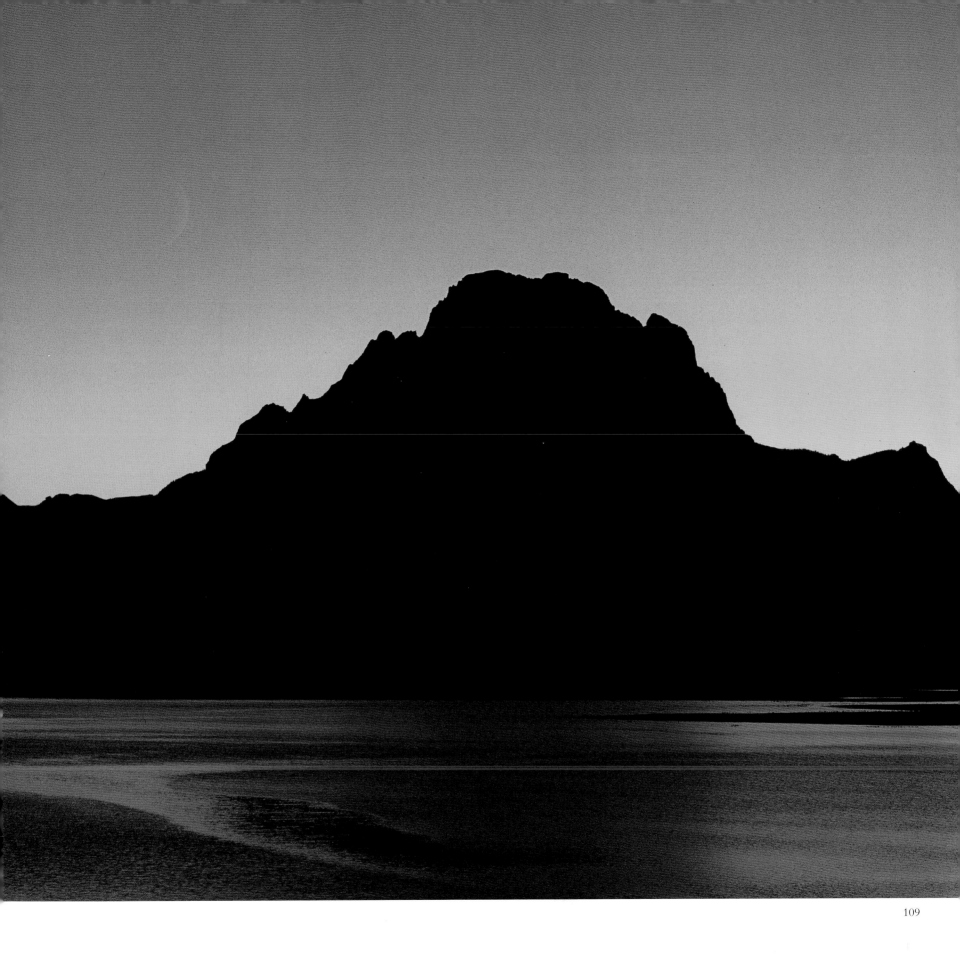

Above: The town of Kelly, just to the east of Grand Teton National Park, was a bustling little community until the great flood of May 18, 1927, when the natural dam at Slide Lake burst, sending a wall of water down the Gros Ventre River that swept away most of the town. Today, Kelly is a residential neighborhood with private homes, ranches, yurts, an elementary school, and a few historic buildings.

Right: Hungry Jack's General Store, which promises "a little bit of everything," has been a fixture of downtown Wilson since 1954. First established across the street in what is now Nora's Fish Creek Inn, the store moved to its present location in 1965. The town itself was named after Elijah Nichols "Uncle Nick" Wilson, who lead the first covered wagons over the Teton Pass in 1889 and owned the town's first hotel, general store, and post office.

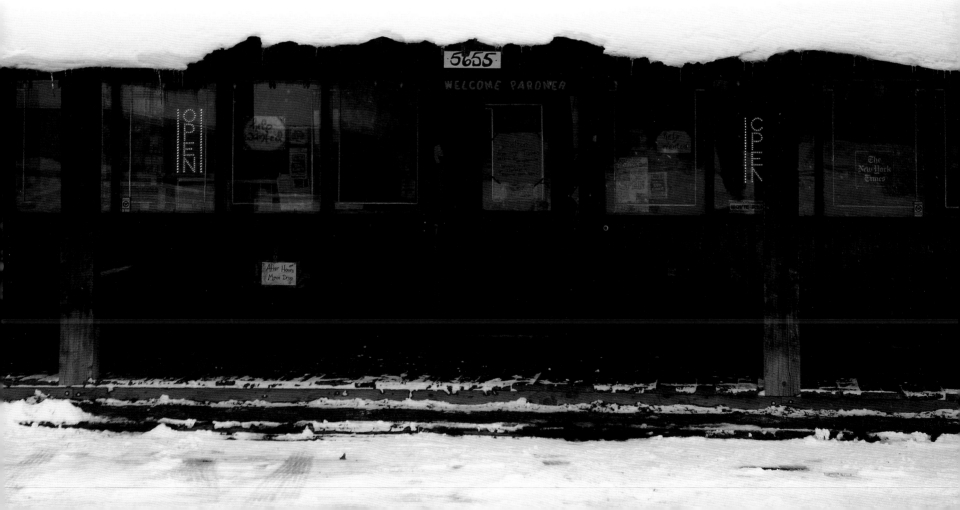

Right: A golden retriever seems to whisper secrets to this snowman sporting elk antlers. Most of the valley's heavy snowfall comes down in flakes that are light and powdery, so there are few occasions when the snow is wet enough to make a snowman.

Far right: The Sleeping Indian seems to dream of days gone by, when scores of bison roamed the West.

Below: A grizzly bear comes out of hibernation to a snowy greeting. In spring and fall, grizzlies can sometimes be seen in the northern Tetons.

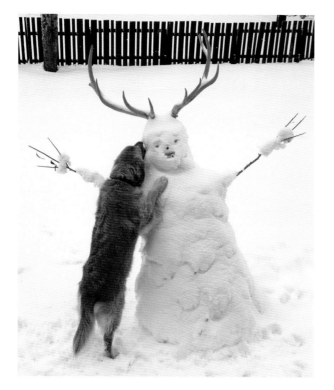

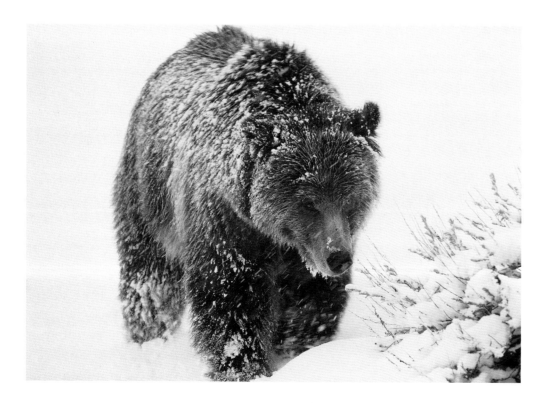

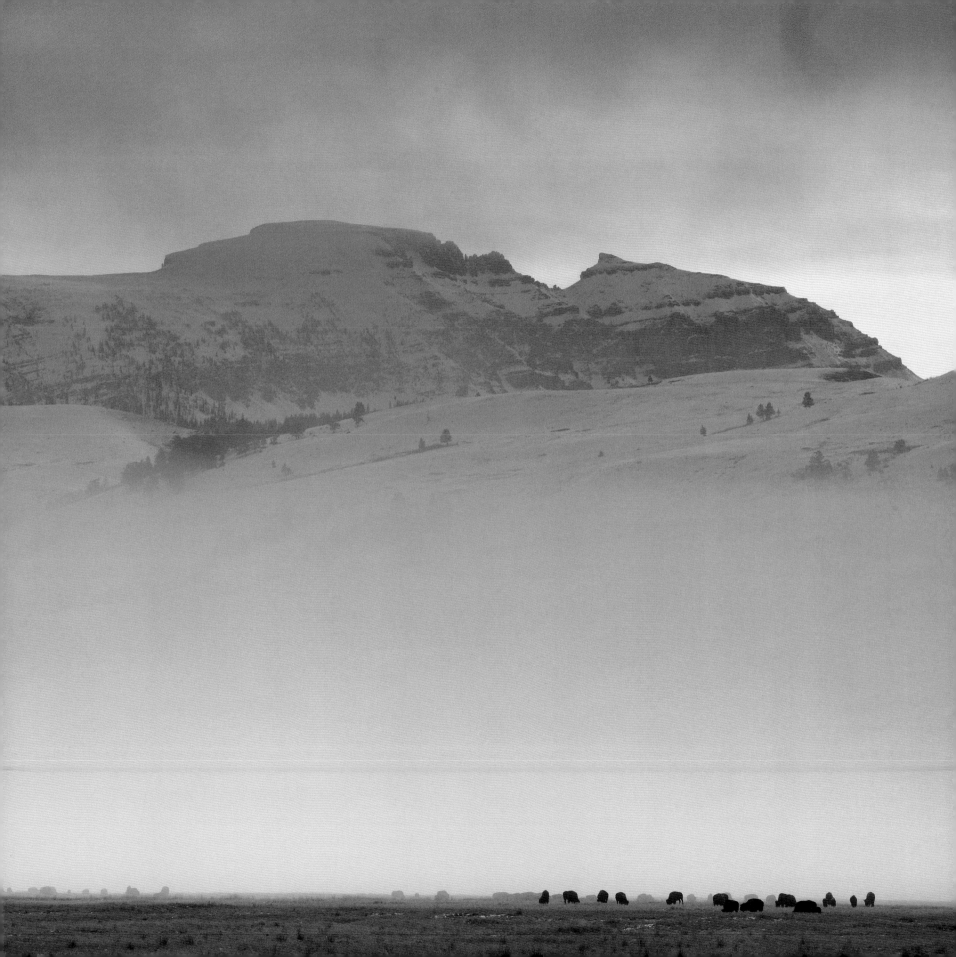

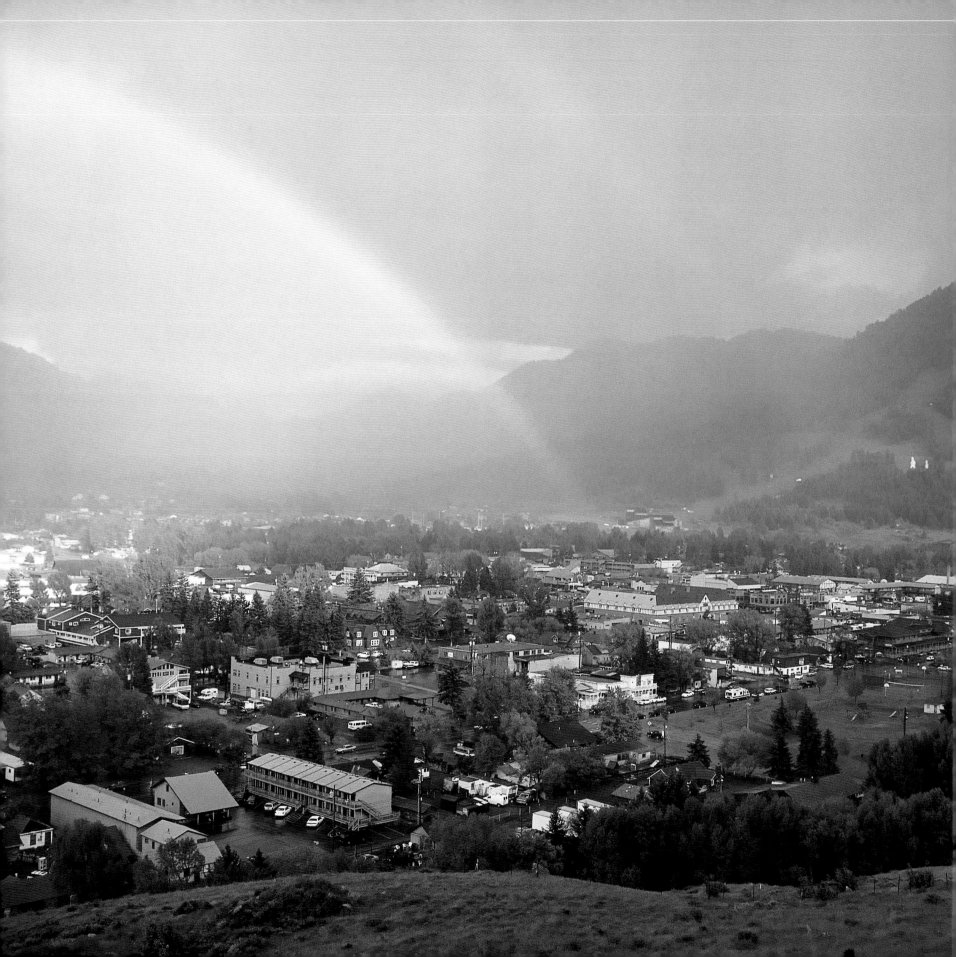

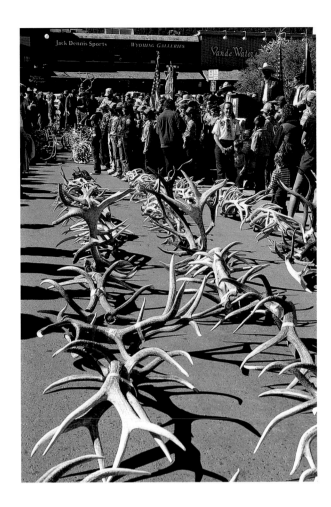

Right: Each May, Boy Scouts gather and auction off elk antlers that were shed on the National Elk Refuge. The proceeds benefit the refuge's supplemental feeding program.

Left: For many residents, Jackson is the end of the rainbow.

Below: With stage coach rides and the oldest running shootout in the country, the Old West experience is alive and well on the Jackson Town Square.

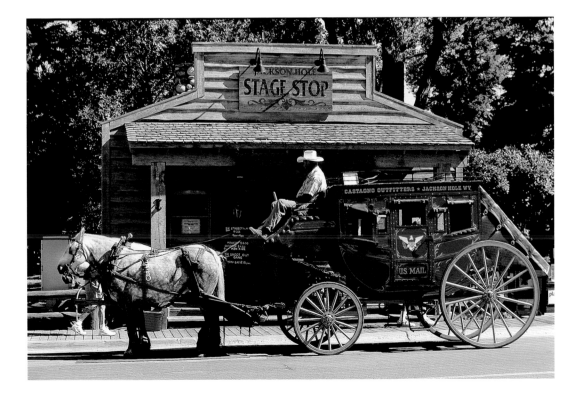

115

Right: A lone bull bison heads south as November snows begin to fill the high country.

Above: Images of the Old West: a barbed-wire coil wrapped around a buck-rail fence. Buck-rail fences were an easy way for settlers to build fences without having to dig into the rocky ground.

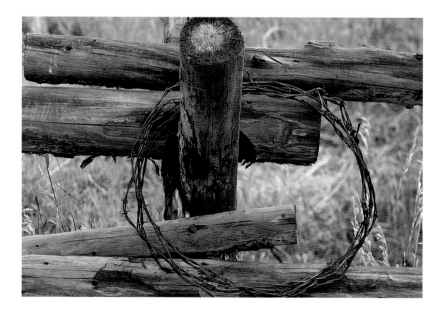

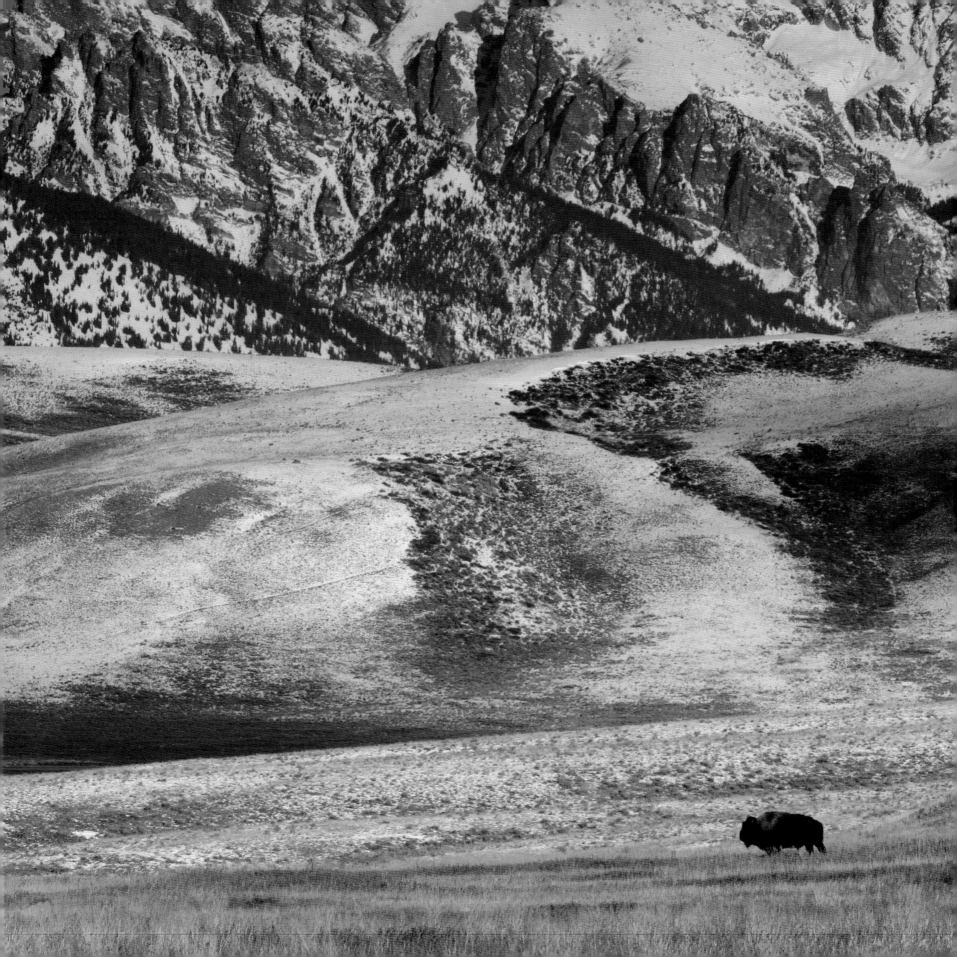

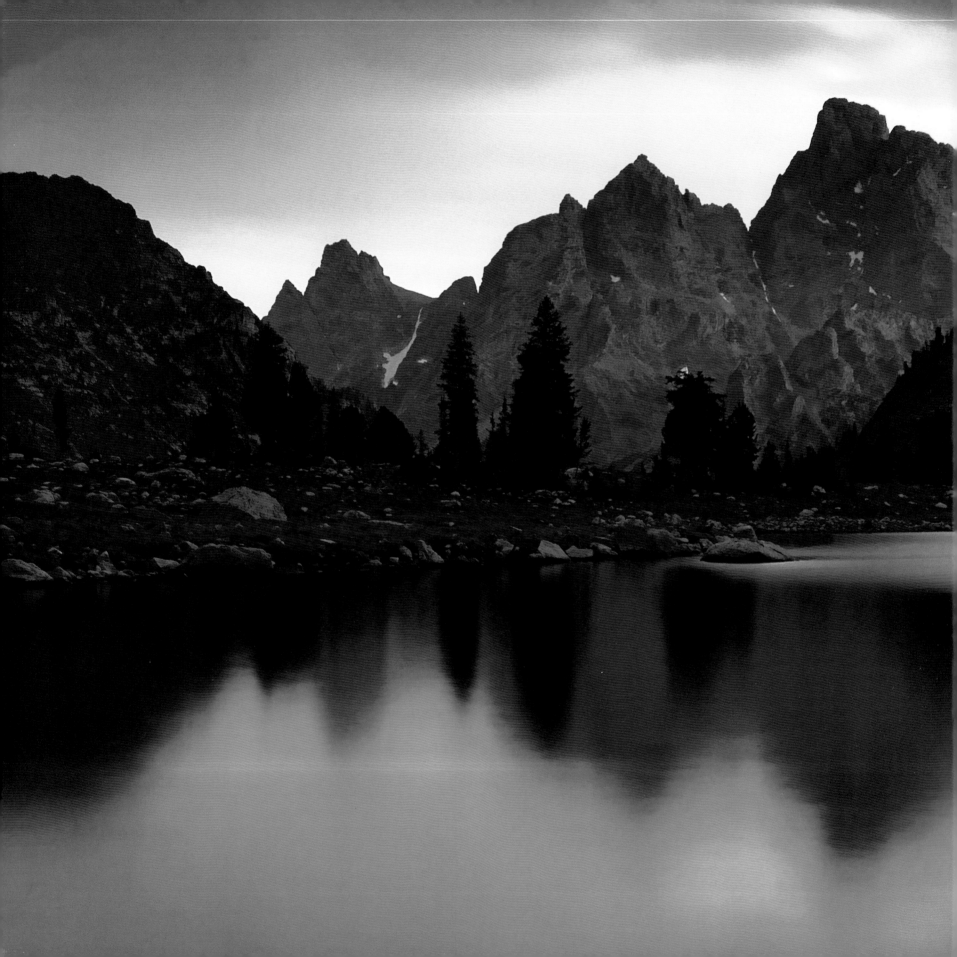

Left: A perfect example of why this is named Lake Solitude.

Below: Hardy early wildflowers such as this low larkspur must be able to survive cold spring storms.

Following page: Summer rain puts on a show at sunrise over Jackson Hole and the Teton Range.

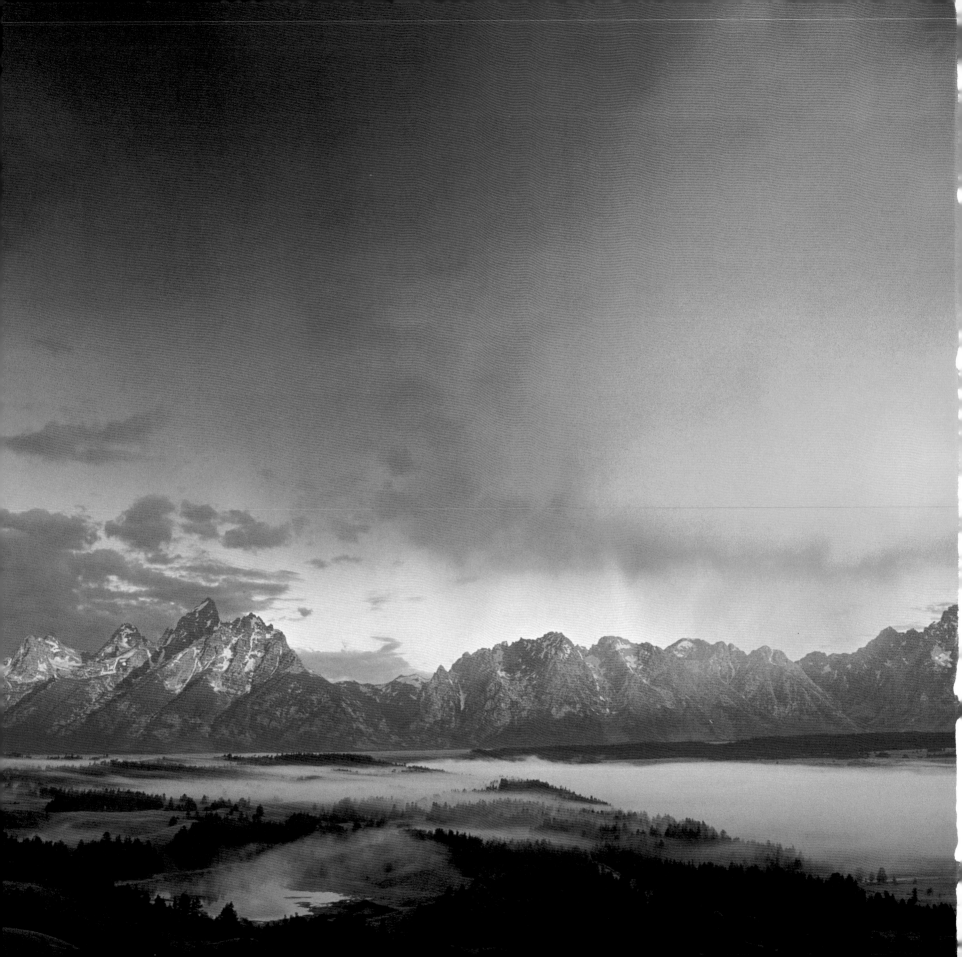